Hand-Lettering Lessons

SUPER-EASY MODERN Calligraphy + PRINT with TRACEABLE ALPHABETS

CAROLINE BRYAN
Author of *Hand-Lettered Home*

CASTLE POINT BOOKS
NEW YORK

www.castlepointbooks.com

The Castle Point Books trademark is owned by Castle Point Publications, LLC.
Castle Point books are published and distributed by St. Martin's Press.

ISBN 978-1-250-27130-3

Design by Joanna Williams
Photography and lettering art by Caroline Bryan
Borders and background textures used under license from Shutterstock.com

Our books may be purchased in bulk for promotional, educational, or business use.
Please contact your local bookseller or the Macmillan Corporate and Premium Sales Department
at 1-800-221-7945, extension 5442, or by email at MacmillanSpecialMarkets@macmillan.com.

First Edition: 2020

10 9 8 7 6 5 4

Contents

Welcome

HAVE YOU EVER THOUGHT, I couldn't possibly learn to hand letter because *my handwriting is nowhere near that gorgeous*? You're not alone. It's the most common misconception I hear about lettering. But here's the secret: You can have terrible handwriting but create lovely hand lettering.

Trust me, I've always longed for that neat, clear writing with the pretty a's and round letters, compared to my messy, rushed scribble that dates back to grade school. I think that's what first drew me to lettering—it was a way to transform the ordinary into something beautiful. You can discover the beauty of hand lettering too! All you need to do is train your hand to follow a new way of forming letters. It takes practice and pacing, but everyone can learn to letter. I'm excited to be your guide as you make your way through the practice pages in *Hand-Lettering Lessons*!

I designed this book with two types of letterers in mind. If you are new to lettering, welcome! I'll see you in Chapter 1, where you will get started with an introduction to brush pens and lettering alphabets for large and small brush pens. Already familiar with brush pens and lettering but would love to add new styles to your repertoire? Jump ahead and join me in

Chapter 2. Wherever you start, you'll find alphabet practice sheets, practice words, and composition hints for every lettering style—using both brush pens and bullet tip pens—with 17 styles total! You'll bring together all the lettering skills you've gained in a fun final section about blending styles and choosing alphabets for a composition.

No matter where you are in your lettering journey, I hope this book encourages you and helps you grow in your skill. Before we get started, here are a few of my favorites pieces of lettering advice.

1. START SMALL, MAKE PROGRESS.

It is always worth remembering that practice makes progress. Lettering, like any artistic craft, takes time and practice for muscle memory to develop. You aren't going to see improvements overnight, but you will see amazing progress

over time. Keep a folder with images of your lettering and refer back to it. Try lettering the same phrase on the first of each month. Celebrate improvements like less-wobbly letters and more confident upstroke/downstroke transitions.

2. EMBRACE A COMMUNITY.

Art is always better shared, right? Form a lettering club of friends that meets once a month. Look for an online community that joins together for monthly lettering challenges. Find a group that inspires you to practice, practice, practice. The best way to stick with learning to letter is to connect with a circle of people who share your interest.

3. COMMIT TO A STRETCH GOAL.

Think about how you can share your lettering and challenge yourself to grow. When I was still fairly new to lettering, I noticed that the yoga studio near my house had a less-than-attractive bulletin board. I nervously walked inside and offered my lettering in exchange for yoga classes. It turned into an amazing experience! I was challenged to come up with new designs each month, and I got practice working with a client. Put your skills to the test and offer to letter for a birthday party, bridal shower, school fundraiser, or dinner party. Stretch goals bring new excitement to lettering and can pull you out of a creative rut.

Whatever your initial motivation for learning lettering, I hope you embrace the new experiences that will come along with it. Lettering has connected me to so many new opportunities—creating beautiful pieces for weddings, wood signs for home decor, signs for local businesses, digital art for friends, workshops and lettering clubs for students, even two published books. But do you know what brings me the most joy? Teaching hand lettering to others, like you!

Happy lettering,

Caroline

Visit me: instagram.com/carolettering • etsy.com/shop/carolettering

Brush Pen Lettering Basics

BRUSH LETTERING IS OFTEN CONFUSED with cursive writing. It's true that they are similar in how the beautiful letters are connected and flow from one to the next. However, the goal of cursive writing is to write quickly without picking up the pen. Brush lettering is much slower and more deliberate. In order to focus on letter formation, you'll want to pick up your pen after each stroke. Here's what else you need to know to get started.

CHOOSING BRUSH PENS

Brush pens can be most widely categorized into two major types: large and small. The calligraphy alphabets in this chapter (beginning on page 12) are designed for these types. When brush lettering, any pen with a flexible brush tip may be used. You'll find many different types of pens on the market. My experience has helped me find some favorites.

- **LARGE BRUSH PENS I RECOMMEND:** Tombow Dual Brush Pen, Stained by Sharpie brush pen, Sakura Koi Coloring Brush Pen, Royal Talens Ecoline Brush Pen

- **SMALL BRUSH PENS I RECOMMEND:** Pentel Fude Touch Sign Pen, Zebra Funwari Super Fine brush pen, Tombow Fudenosuke Calligraphy Brush Pen

As interest in brush lettering continues to grow, new brands continue to be released. Your best approach is to pick one large brush pen and one small brush pen of the same brand, then

SECRETS TO LASTING PENS

All brush pens will fray with time and use, but caring for your pens will help them last longer. Stick with lettering on smooth paper to keep your pens from fraying. You can use tracing paper on top of these practice pages to lengthen the life of your brush pens. Lettering on marker paper or 32-lb laser-jet paper also works well to maintain your pens' integrity.

learn with that brand before trying to switch around. It takes time to get used to how a brush pen responds, so learn the basics first. Once you have a good handle on brush lettering technique, have fun exploring and finding new brands that you love.

Don't worry: the pen isn't the be-all and end-all. With practice, you can learn to use even simple Crayola broad tip markers to get a brush pen look! Rather than spending time and money searching for the perfect pen, pick one and pick it up often to start advancing your lettering skills to work with any type of pen.

KEYS TO BRUSH LETTERING

Your best lessons will come as your brush pens hit paper. As you get started, keep in mind:

- **UPSTROKES ARE THIN.** Downstrokes are thick. Translated into your technique: apply very light pressure on the upward sweeping motions to form the upstroke. Apply firm pressure and pull downward to form the downstroke. You will see the tip of the pen

bend on the downstrokes. Write slowly to make these transitions more pronounced.

- **YOUR BEST RESULTS COME FROM WORKING THE ANGLE.** Fight the urge to hold the pen straight up and down to get thin upstrokes; it damages the pen tip and teaches bad lettering habits. Instead, hold your pen so that the tip is at a 45-degree angle to the paper; then rely on the pressure you apply to the pen to get thin and thick lines.

Start by simply practicing some strokes to learn the fundamentals of using a brush pen and the building blocks for letters. The Large Brush Drills (page 9) and Small Brush Drills (page 29) are great practice sheets to help build muscle memory. Once you feel comfortable with a brush pen, focus on the lowercase alphabet first. Practice forming each letter and then work on connections. After gaining confidence with a lowercase alphabet, move on to the uppercase letters. The practice pages beginning on page 12 will guide you through both lowercase and uppercase calligraphy for large brush pens and small brush pens.

LARGE BRUSH DRILLS

Practice these drills often to help build muscle memory. Work slowly and focus on achieving thin upstrokes and thick downstrokes.

Wobbly lines are normal! Try turning your book at an angle and working on a slant. This simple step can help as you practice upstroke and downstroke lines.

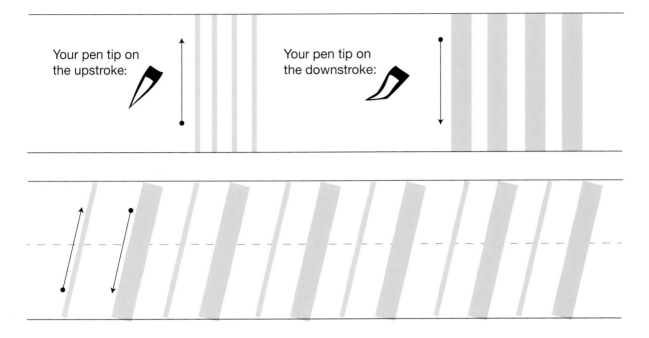

Your pen tip on the upstroke:

Your pen tip on the downstroke:

OVERTURN: Begin with very light pressure. At the top of the arch, begin to add pressure. By the dotted line you should be pulling downward with full pressure to create a downstroke.

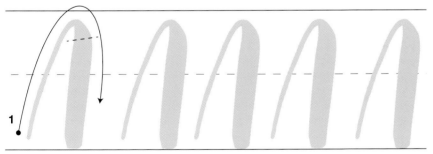

1

Listen for the squeak of the pen dragging on the paper and look for a bend in the pen's tip when making a downstroke.

UNDERTURN: Start with heavy pressure as you drag the pen downward. Lighten the pressure at the dotted line and as you turn. Finish with very light pressure to create the thin upstroke.

Overturns and underturns help you practice transitioning between light-pressure upstrokes and heavy-pressure downstrokes without lifting the pen.

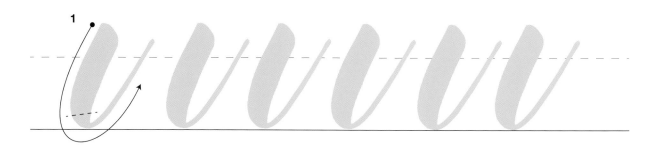

OVALS: For this tricky stroke you need to make two full transitions—from light upstroke to heavy-pressure downstroke, then back to light upstroke again. When you first work through these drills, focus on those transitions. Begin at the dot. Apply light pressure as you begin the oval, moving counterclockwise. Transition into the downstroke by applying more pressure and pulling the pen downward. Begin to let up pressure at the dotted line so that when you turn into the upstroke you are applying very light pressure, just like when you started.

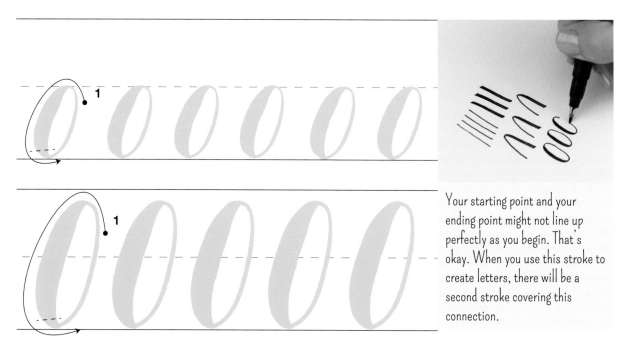

Your starting point and your ending point might not line up perfectly as you begin. That's okay. When you use this stroke to create letters, there will be a second stroke covering this connection.

DESCENDER: Begin with heavy pressure, then transition to light pressure.

Aim for your thick downstroke to cover your beginning point.

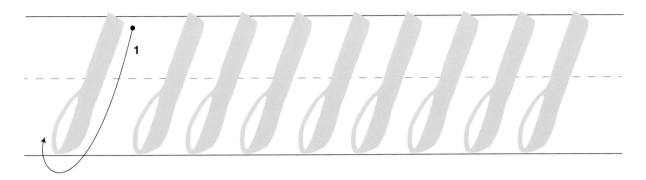

ASCENDER: Begin with light pressure, drawing the pen up, and begin a transition to heavy pressure as you pull the pen downward.

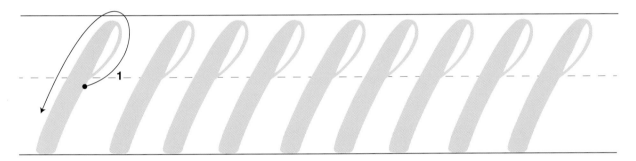

Calligraphy with Large Brush Pens

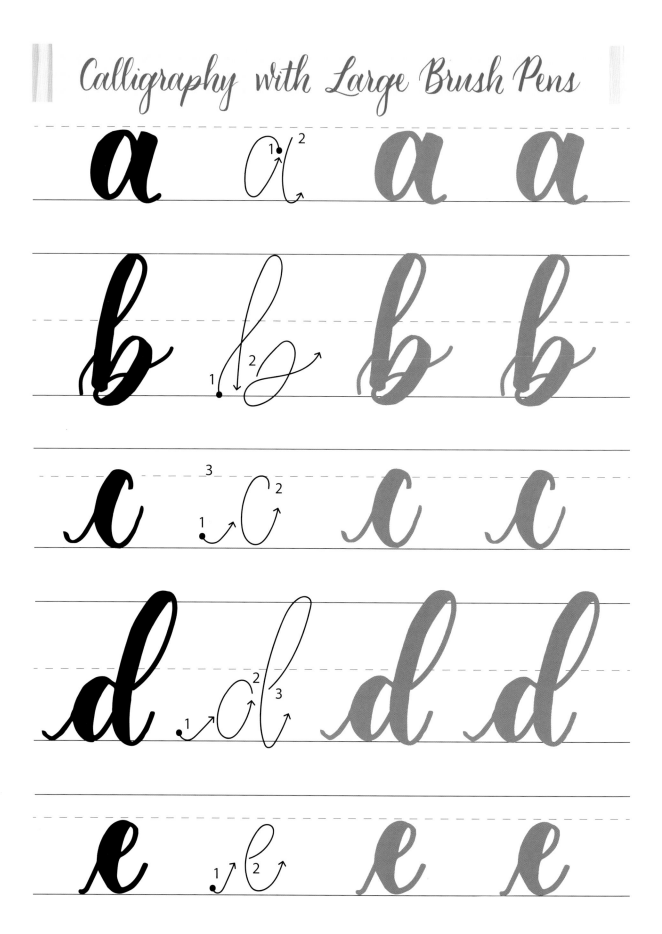

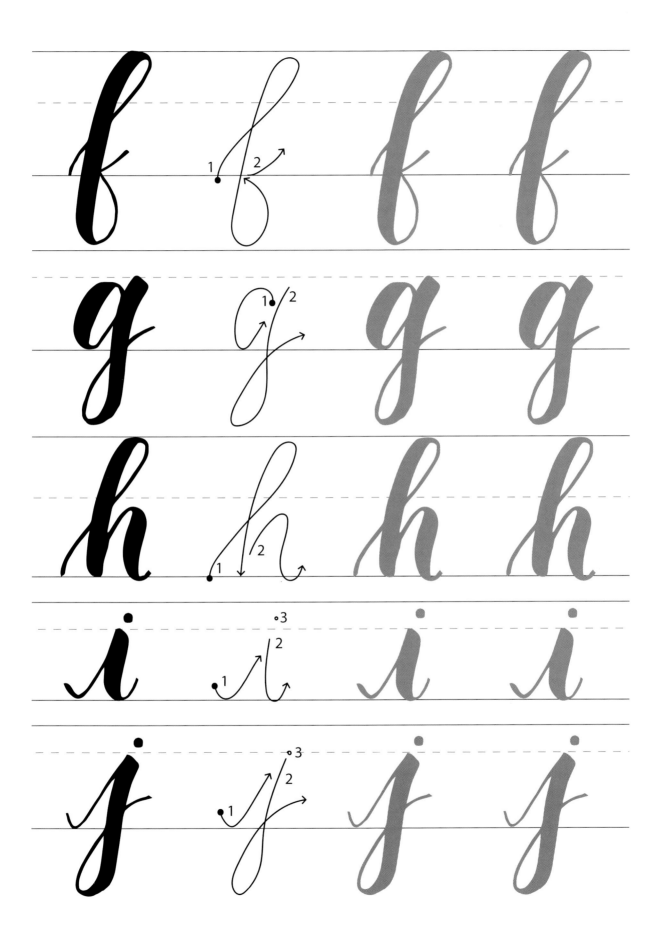

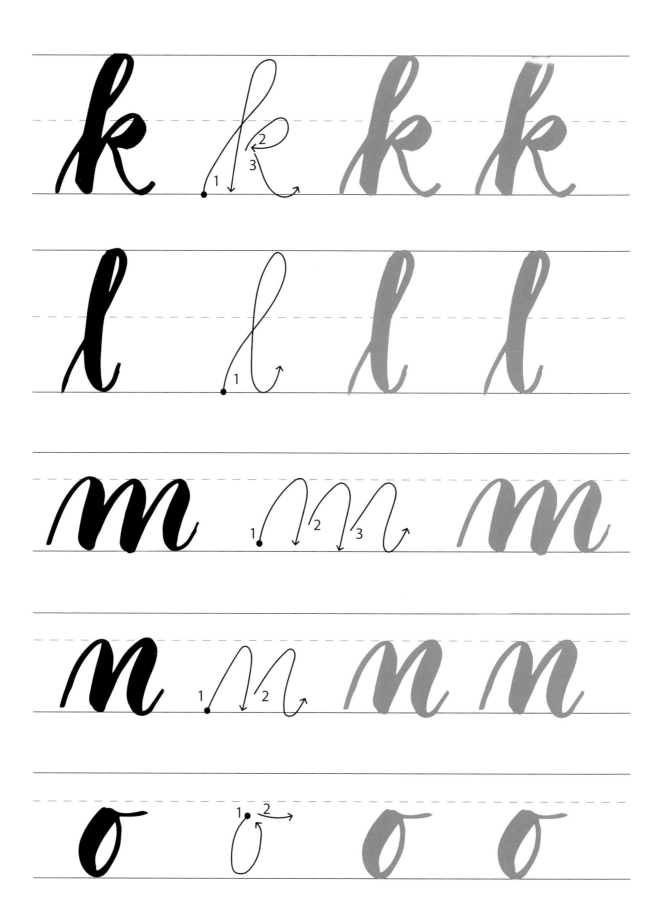

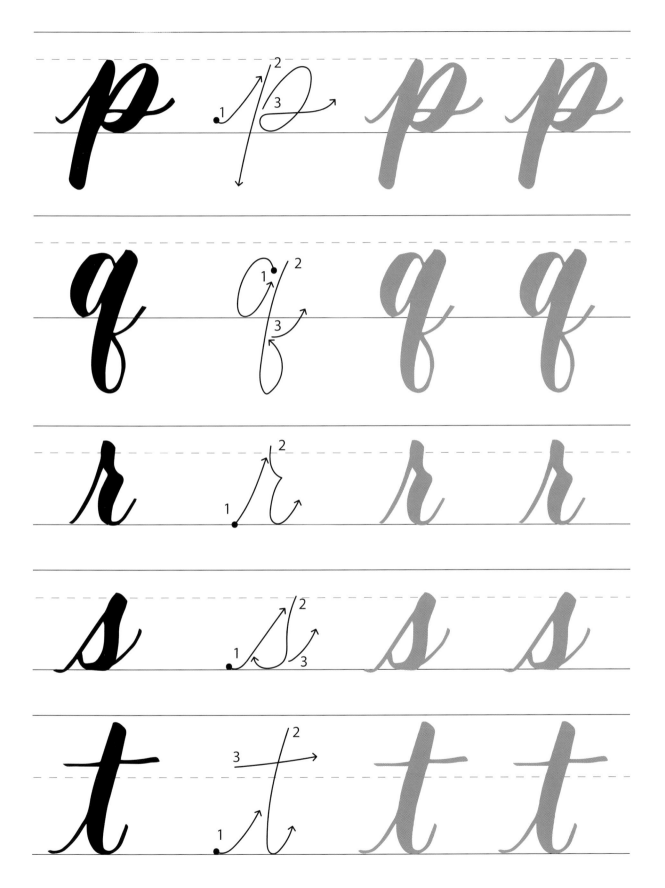

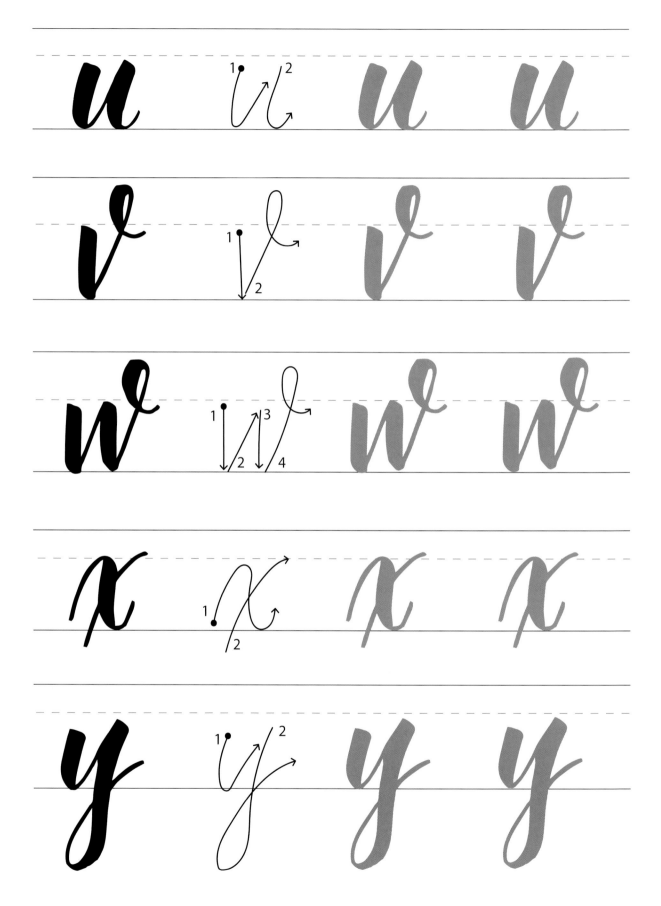

3 3 3 3

12345

67890

12345

67890

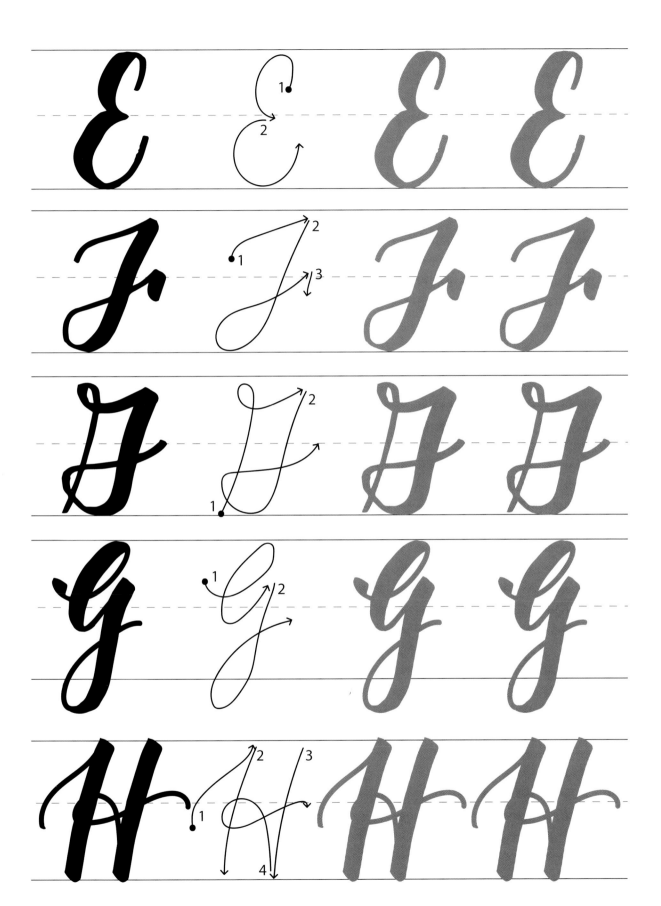

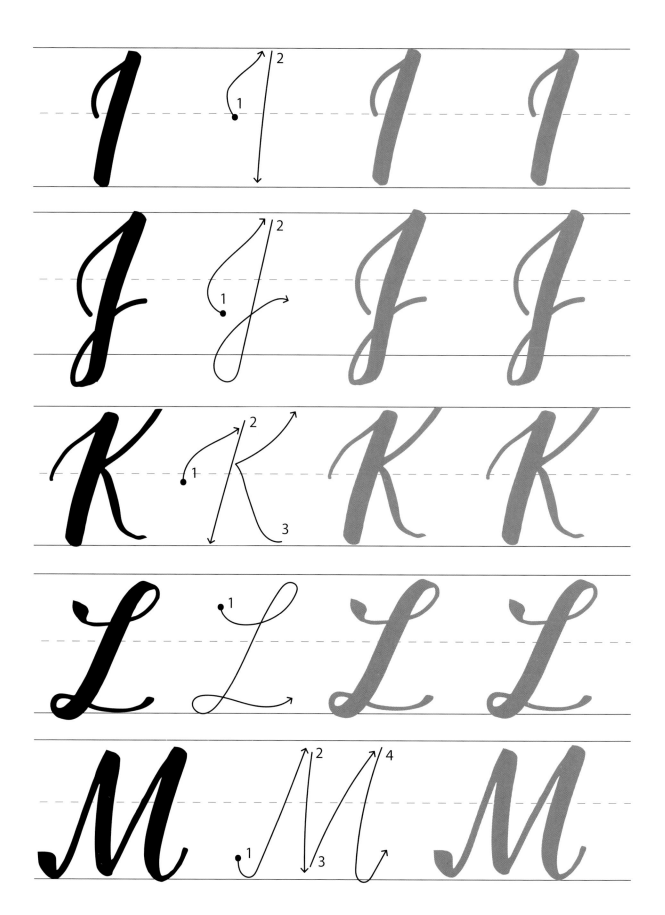

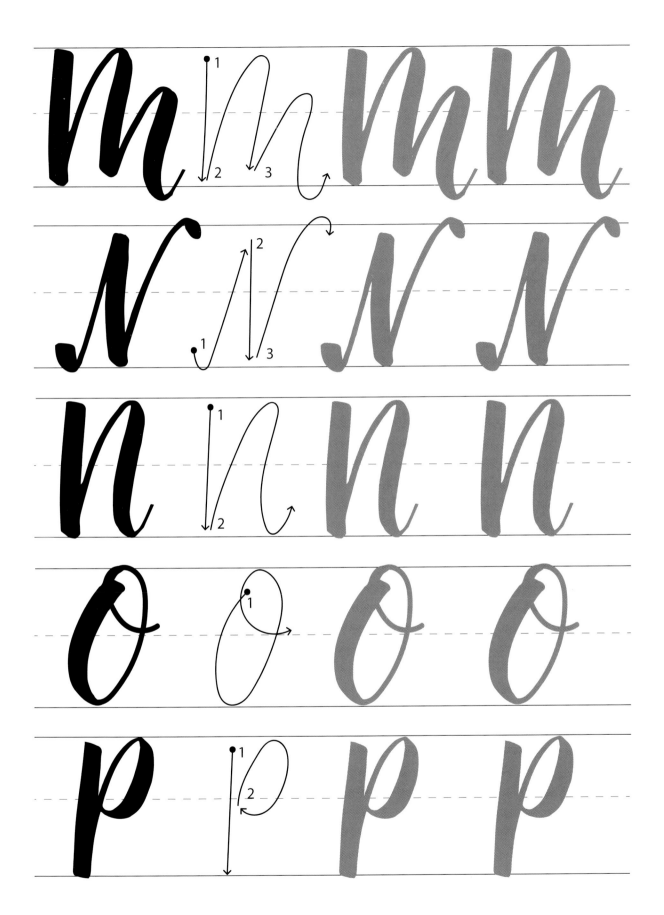

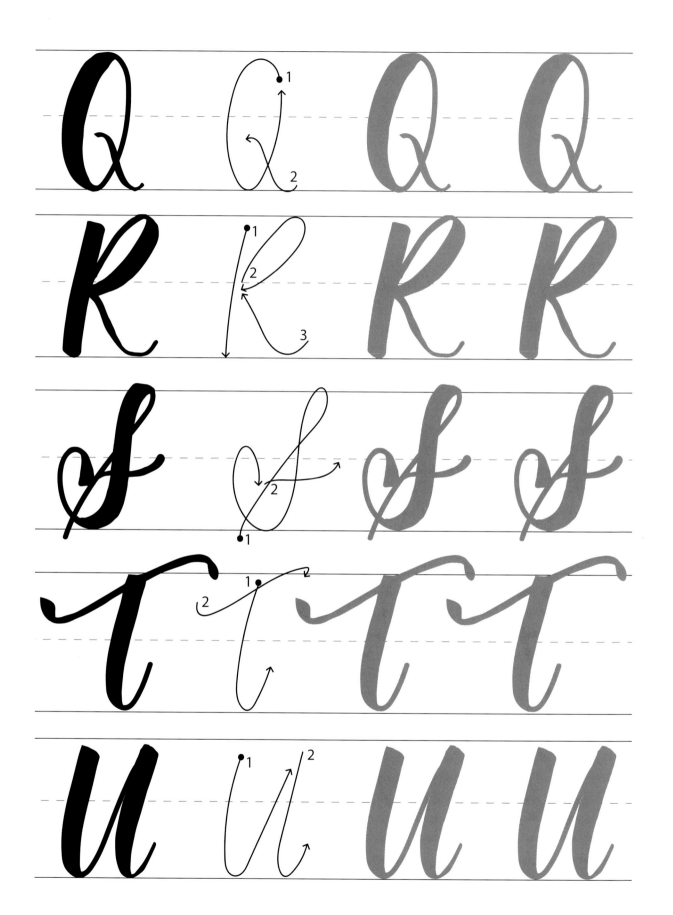

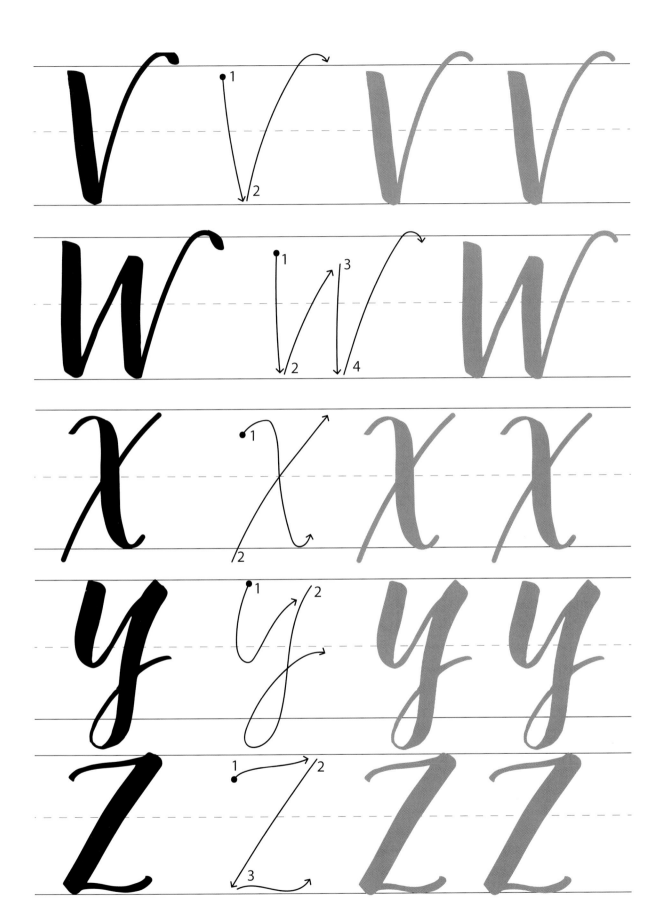

CONNECTING LETTERS TO FORM WORDS: Begin with couplets. For many letter combinations, you will connect the letters with a thin upstroke to a thick downstroke. Remember to work slowly and to lift your pen between strokes, sometimes mid-letter but also between letters.

Whenever possible, cover the connection point between letters with a thick downstroke. I plan my second letter to overlap the very end of the thick upstroke from the previous letter. You can see this with the color changes below. This technique gives a smooth, seamless transition.

bi b b

ch c c

ng n n

fo f f

PRACTICING SPECIAL CONNECTIONS: Not every letter combination is going to allow for a thin upstroke to connect with (and be covered by) a thick downstroke. The letters m, n, r, s, x, and z need special attention for connections. Practice these letter combinations below. I broke down the strokes by color changes. Remember to work slowly and lift your pen each time you encounter a new color.

am o n

en en en

dr o r o r

cs c c

ox o o o o

uz v y v y

hello hell hell

hello hello

the *the*

and *and*

was *was*

you *you*

are *are*

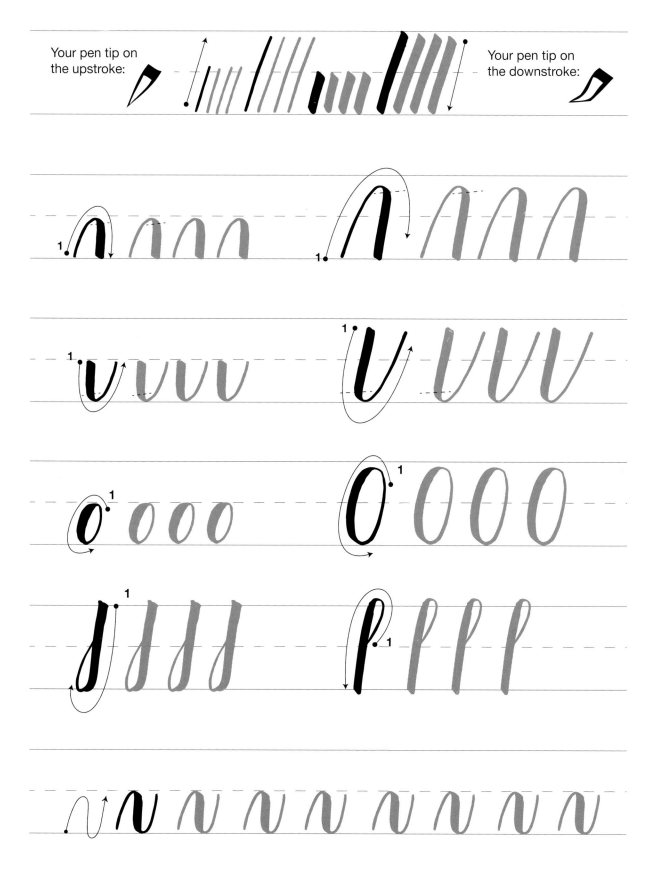

Your pen tip on the upstroke:

Your pen tip on the downstroke:

Calligraphy with Small Brush Pens

a a a a a a a

b b b b b b b

c c c c c c c

d d d d d d d

e e e e e e e

f f f f f f f

g g g g g g

h h h h h h

i i i i i i

j j j j j j

k k k k k k

l l l l l l

m m m m m m m

n n n n n n n

o o o o o o o

p p p p p p p

q q q q q q q

r r r r r r r

s s s s s s

t t t t t t

u u u u u u

v v v v v v

w w w w w w

x x x x x x

y y y y y y y

z z z z z z z

12345

67890

12345

67890

$$a \quad a \quad a \quad a \quad a$$

$$B \quad B \quad B \quad B \quad B$$

$$C \quad C \quad C \quad C \quad C$$

$$D \quad D \quad D \quad D \quad D$$

$$E \quad E \quad E \quad E \quad E$$

$$F \quad F \quad F \quad F \quad F$$

G G G G G

H H H H H

1 1 1 1 1

J J J J J

K K K K K

L L L L L

Mmmmm

Nnnnn

Ooooo

Ppppp

22222

RRRRR

S S S S S

S S S S S

T T T T T

U U U U U

V V V V V

W W W W W

X X X X X

Y Y Y Y Y

Z Z Z Z Z

as as as as

to t to to

by by by by

re re re re

ch ch ch ch

pi p pi pi

the the the

and and and

you you you

that that that

was was was

are are are

Next Steps in Brush Pen Styles

ONCE YOU CAN CONFIDENTLY TRANSITION between thin upstrokes and thick downstrokes with a brush pen, the next step is to add variety to your lettering. Learning a mix of lettering styles challenges your brush pen control, helps keep you motivated to practice, and can also lead to more interesting and sophisticated lettering pieces.

READY FOR MORE?

Each alphabet in this chapter has an overview sheet, practice pages, numbers in the alphabet style, and a practice sentence. Here's a quick introduction to the lettering styles you'll meet: The Bouncy alphabet drops letters below the baseline for a fun, modern calligraphy style. The Flow alphabet stretches the distance between letters for a dramatic and romantic look. The letters in the Script alphabet are rounded out horizontally, while the Mountain alphabet stretches tall and vertical. Named for its festive look, the Holiday features fancy end caps. The RSVP alphabet is an uppercase alphabet with swirls and loops. It could be a little much to use to write out an entire quote but looks great when creating monograms or initials paired with an ampersand. Try pairing RSVP with Holiday or even the basic small brush pen alphabet from chapter 1 for longer words or quotes. Brush Print is a print alphabet with a few cursive-style letters. With all of these alphabets, place a piece of tracing paper on top of the book pages and work slowly to practice forming the letters.

abcdefghij

klmnopqr

stuvwxyz

a a a a a

b b b b b

c c c c c

d d d d d

e e e e e

f f f f f

g g g g g

h h h h h

i i i i i

j j j j j

k k k k k

l l l l l

s s s s s

t t t t t

u u u u u

v v v v v

w w w w w

x x x x x

y y y y y

z z z z z

1 2,3 4 5

6 7 8 9 0

1 2,3 4 5

6 7 8 9 0

the quick brown

fox jumps

over a lazy

dog.

a b c d e f g

h i j k l m

n o p q r s

t u v w x y z

a a a a a a a a

b b b b b b

c c c c c c c

d d d d d d

e e e e e e e

f f f f f f

g g g g g g

h h h h h

i i i i i i i

j j j j j j j

k k k k k k

l l l l l l l

s s s s s s

t t t t t

u u u u u u

v v v v v v

w w w w w w

x x x x x x

y y y y y y

y y y y y y

1 2 3 4 5

6 7 8 9 0

1 2 3 4 5

6 7 8 9 0

the

quick

brown

fox

jumps

over a

lazy

dog

ABCDEFGHiJKLMN

OPQRSTUVWXYZ

abcdefghi

jklmnopqr

stuvwxyz

A A A A a a a a

B B B B b b b b

C C C C c c c c

D D D D d d d d

E E E E e e e e

F F F F f f f f

G G G G g g g g

H H H H h h h h

i i i i i i i i

J J J J j j j j

K K K K k k k k

L L L L l l l l

M M M M m m m m

N N N N n n n n

O O O O o o o o

P P P P p p p p

Q Q Q Q q q q q

R R R R r r r r

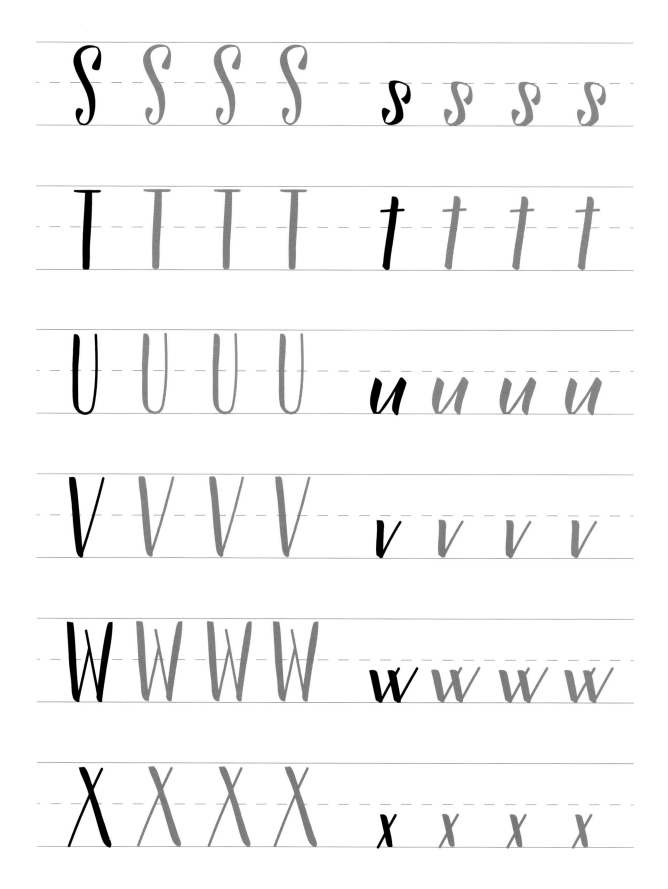

Y Y Y Y Y y y y y

Z Z Z Z Z ʒ ʒ ʒ ʒ

12345

67890

12345

67890

The quick brown fox jumps over a lazy dog.

abcdefghij

klmnopqrs

tuvwxyz

a a a a a

b b b b b

c c c c c

d d d d d

e e e e e

f f f f f

g g g g g

h h h h h

i i i i i

j j j j j

k k k k k

l l l l l

m m m m m

h h h h h

o o o o o

p p p p p

q q q q q

r r r r r

y y y y y

z z z z z

12345

67890

12345

67890

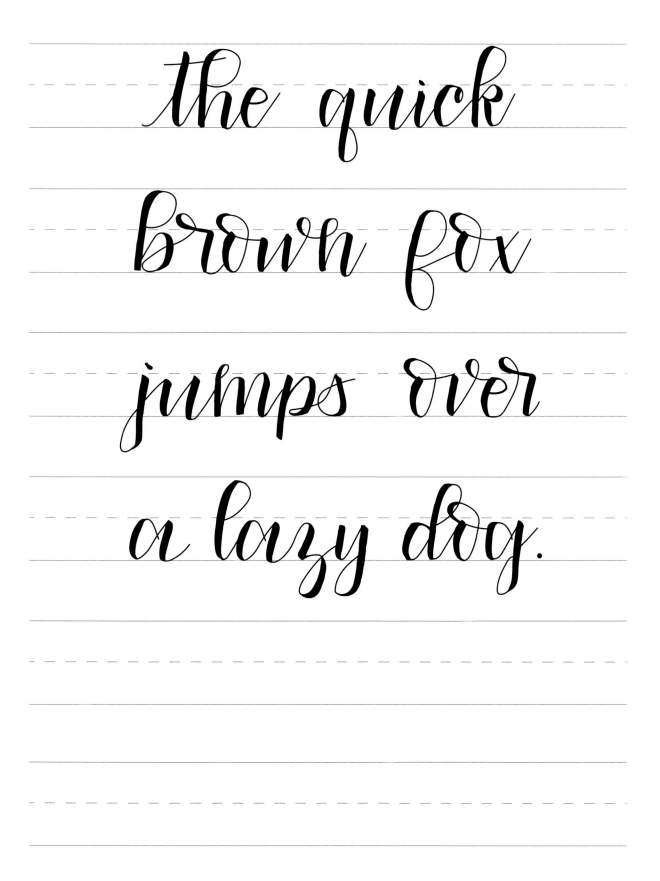

the quick
brown fox
jumps over
a lazy dog.

abcdefg

hijklmn

opqrstu

vwxyz

a a a a a a a

b b b b b b b

c c c c c c c

d d d d d d d

e e e e e e e

f f f f f f f

g g g g g

h h h h h

i i i i i

j j j j j

k k k k k

l l l l l

s s s s s

t t t t t

u u u u u

v v v v v

w w w w w

x x x x x

y y y y y

z z z z z

1 2 3 4 5

6 7 8 9 0

1 2 3 4 5

6 7 8 9 0

the quick brown fox jumps over a lazy dog.

A B C D E

F G H I J K

L M N O P

Q R S T U

V W X Y Z

The alphabet above follows brush-lettering rules of thin upstrokes and thick downstrokes with the flourish as part of the letter. Begin at the dot and continue, following the arrow.

The exceptions to that technique are A, M, and N. To form these letters, you will write the letter first and then add the flourish separately as a second step, as shown below.

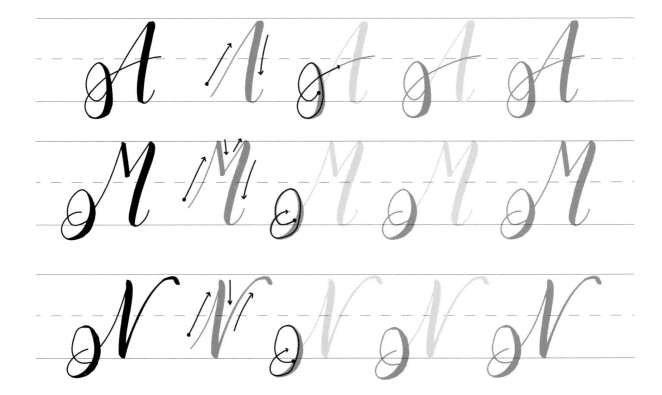

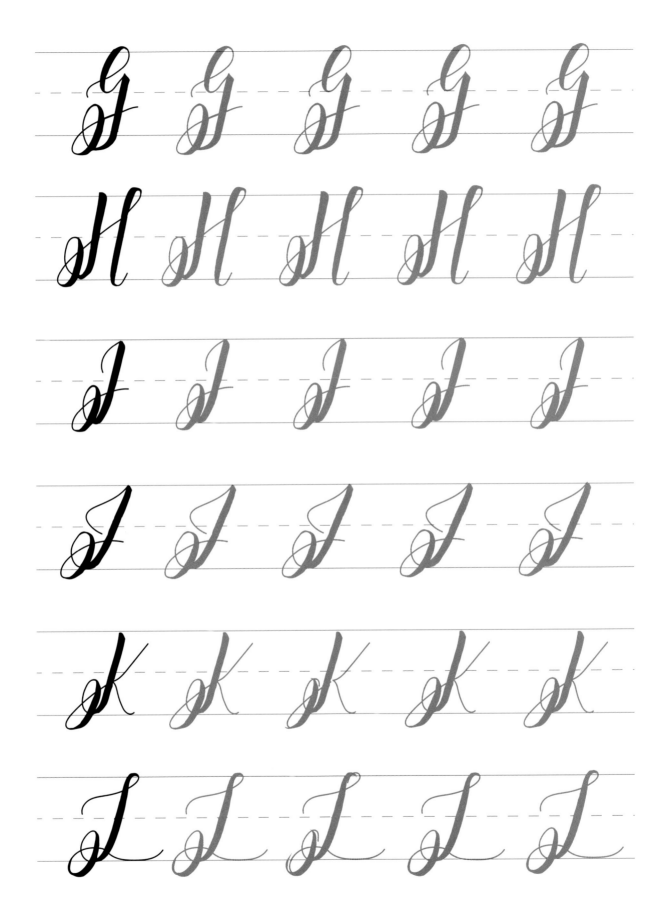

S S S S S

J J J J J

U U U U U

V V V V V

M M M M M

X X X X X

Y Y Y Y Y Y Y

Z Z Z Z Z Z

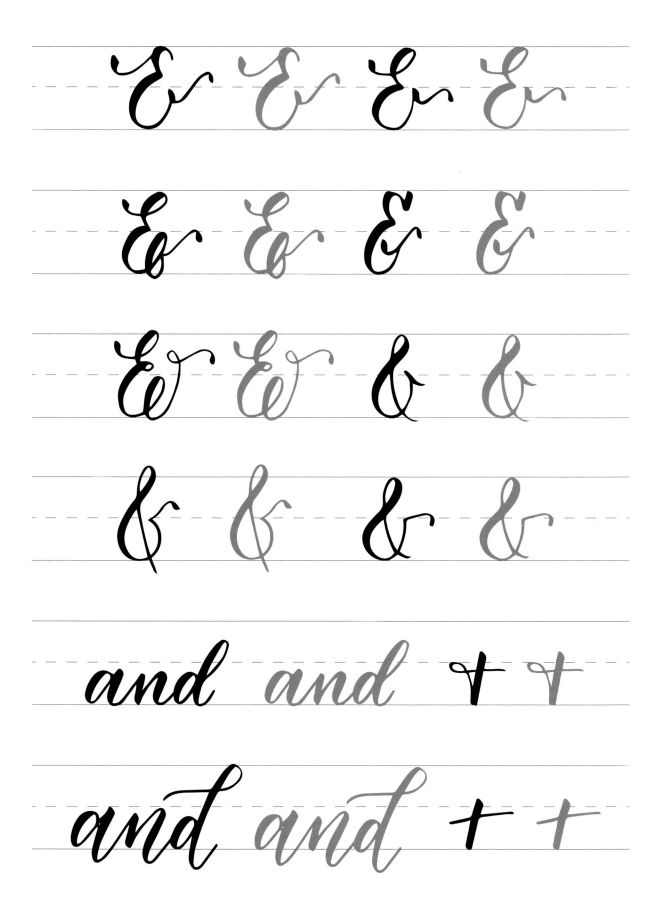

$$R \quad S \quad V \quad P$$

$$G + W$$

$$K + Y$$

$$H \quad \& \quad L \quad C \quad \& \quad J$$

abcdefg

hijklmn

opqrstu

vwxyz

a a a a a a

b b b b b b

c c c c c c

d d d d d d

e e e e e e

f f f f f f

g g g g g g

h h h h h h

i i i i i i

j j j j j j

k k k k k k

l l l l l l

s s s s s s

t t t t t t

u u u u u u

v v v v v v

w w w w w w

x x x x x x

y y y y y y y

z z z z z z z

12345

67890

12345

67890

the quick brown
fox jumps over
a lazy dog.

Lettering with Bullet Tip Pens

THE BULLET TIP PEN ALPHABETS featured in this chapter don't come with as many set-up instructions as the brush pen alphabets. Bullet tip pens don't have a flexible tips, so they won't fray as quickly and also don't require the same pressure changes that are tricky to learn with brush pens. These alphabets do, however, require practice and slow, deliberate letter formation—which the pages that follow will help you develop.

HELPFUL HINTS

My favorite bullet tip pens to use are Sharpie fine point markers, Sakura Gelly Roll pens and Micron pens, Elmer's Painters pens, and the bullet tip side of the Tombow Dual brush pens. No matter what bullet tip lettering style you are learning, use the overview pages to refer back to letters as you work.

Ready for a preview of the styles in this section? Faux Calligraphy creates the look of a brush pen while using a bullet tip—great for sign making with paint pens. Sunshine and Monoline are modern calligraphy alphabets with bouncy twists. Sunshine has dramatic sweeps up while Monoline letters bounce along the baseline. Dot is a whimsical alphabet with rounded ends. Cafe is a clean, rounded, sans serif print, while Craft is a thin, tall, sans serif print. Best formed with a straight edge ruler, Block and Typewriter are both variations on a serif print. Get your tracing paper ready to try a variety of styles!

A B C D E F

G H I J K L

M N O P Q

R S T U V W

X Y Z

a b c d e f

g h i j k l

m n o p q

r s t u v w

x y z

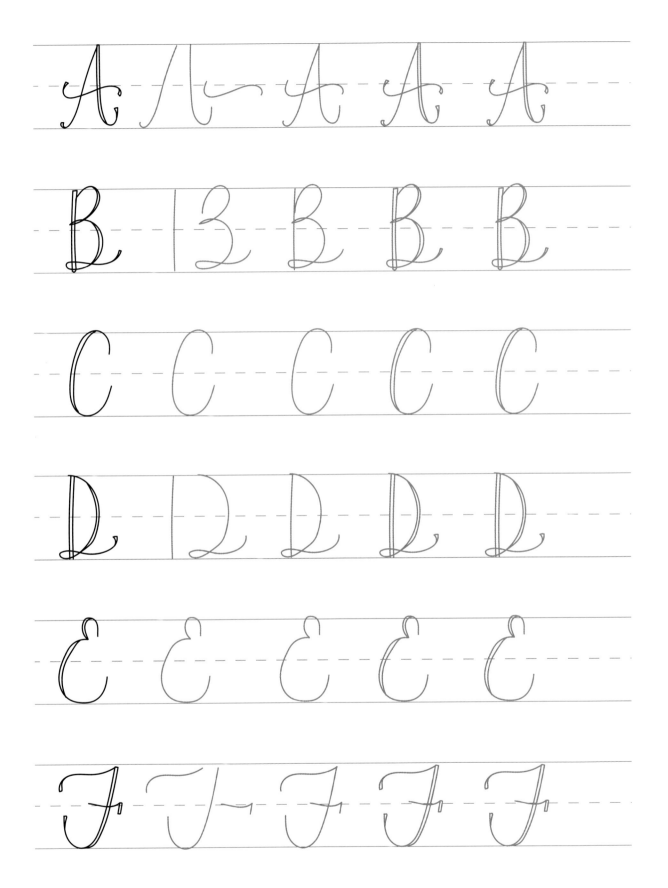

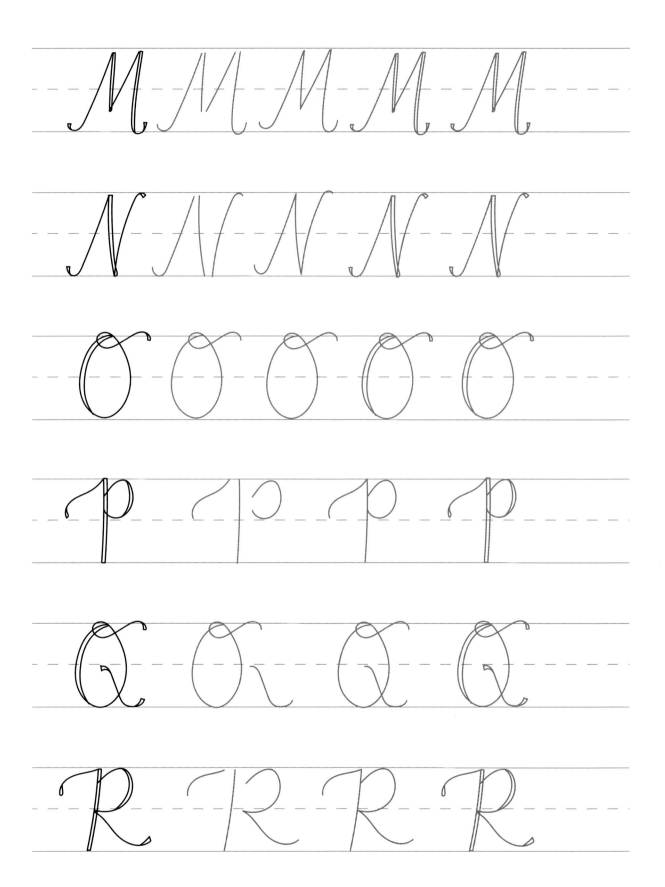

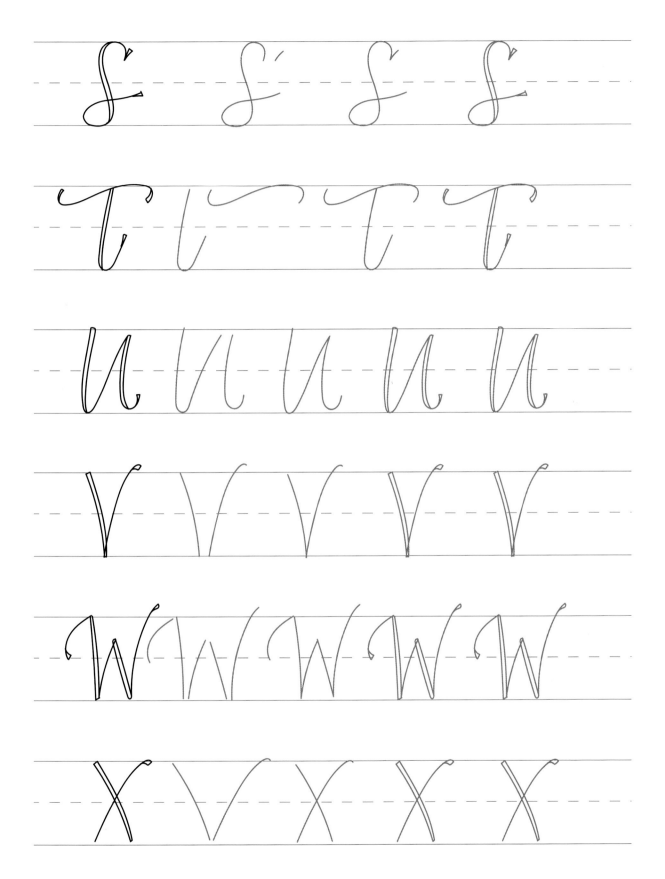

Y Y Y Y Y

Z Z Z Z Z

1 2 3 4 5

6 7 8 9 0

1 2 3 4 5

6 7 8 9 0

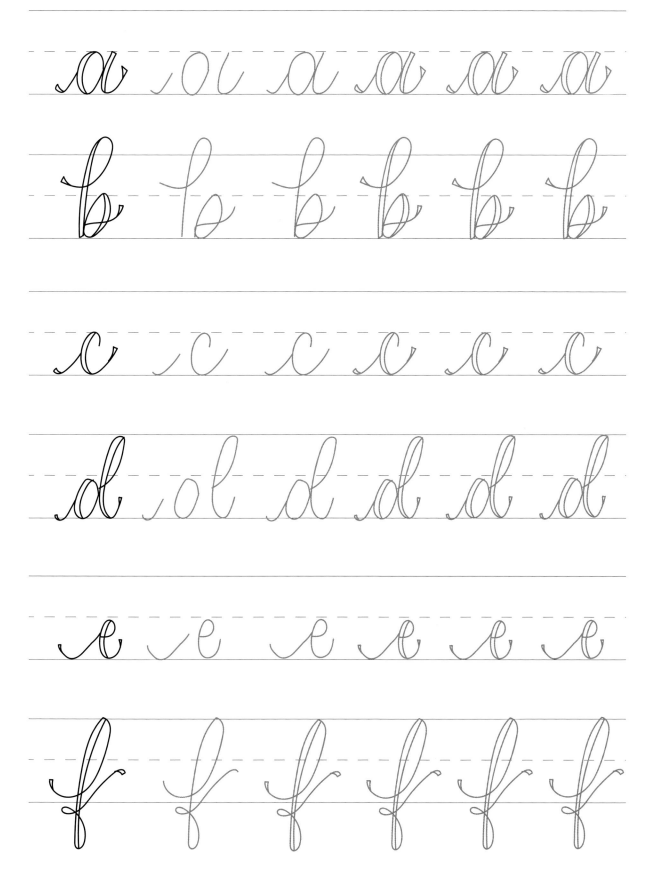

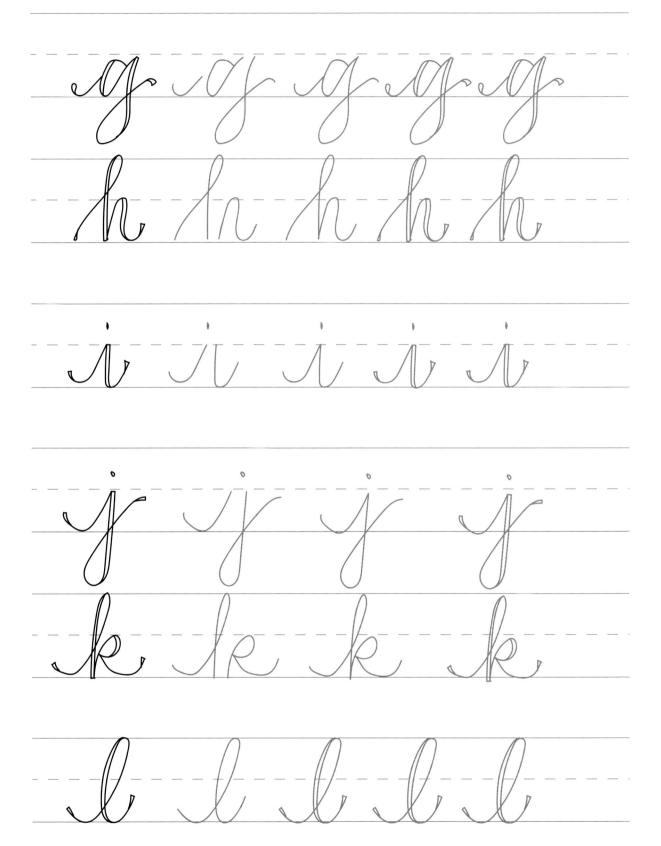

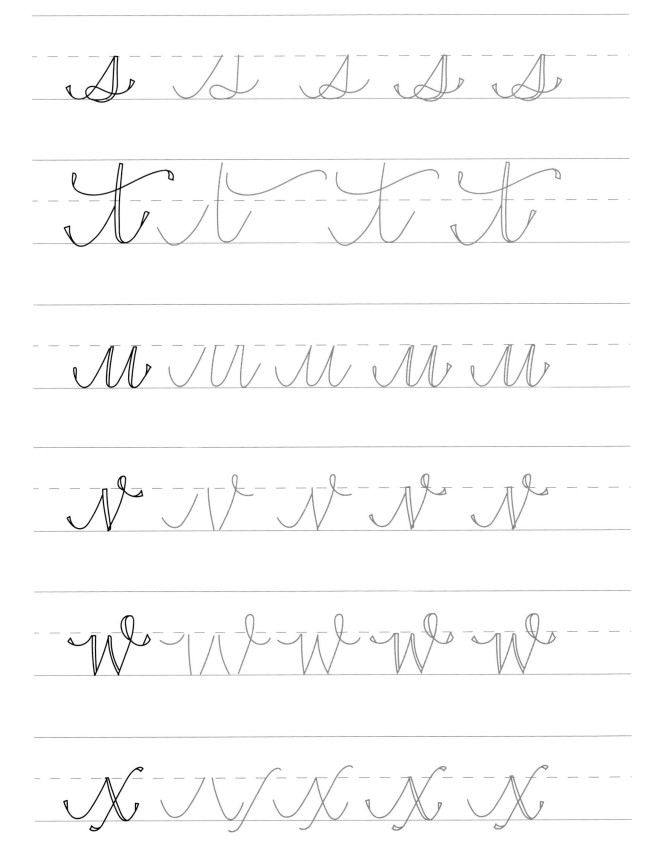

Y Y Y Y Y

Z Z Z Z Z

The quick brown
fox jumps over
a lazy dog.

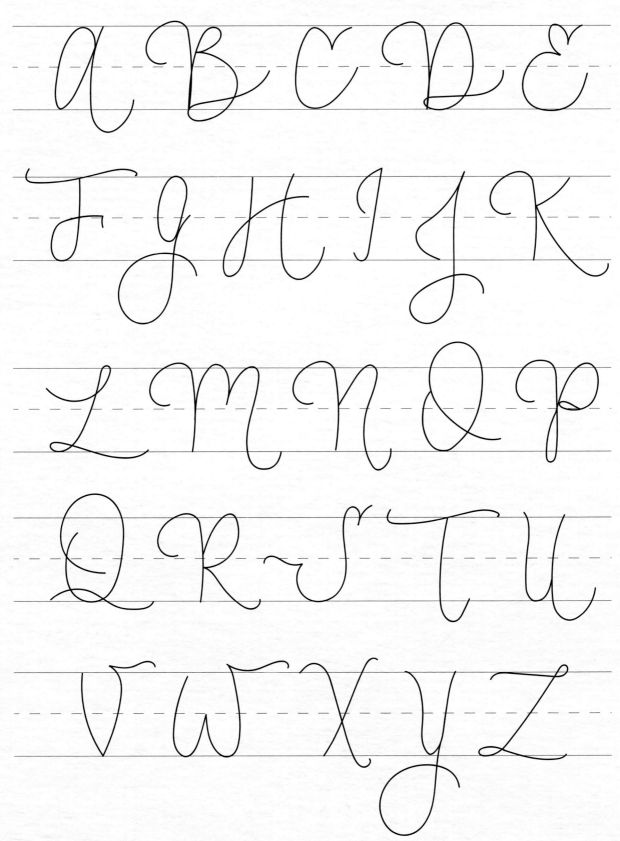

a b c d e f g

h i j k l m n

o p q r s t

u v w x y z

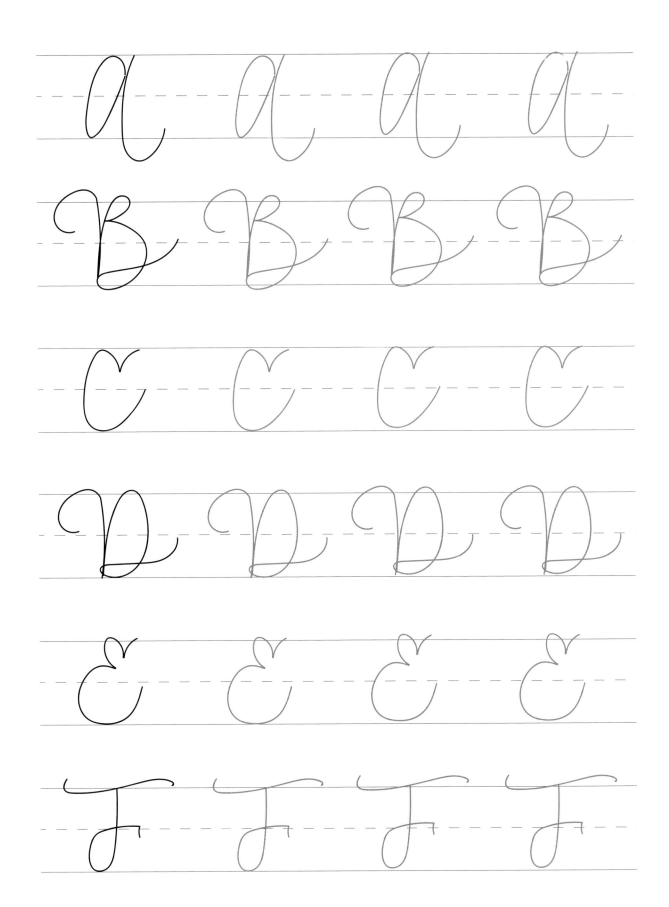

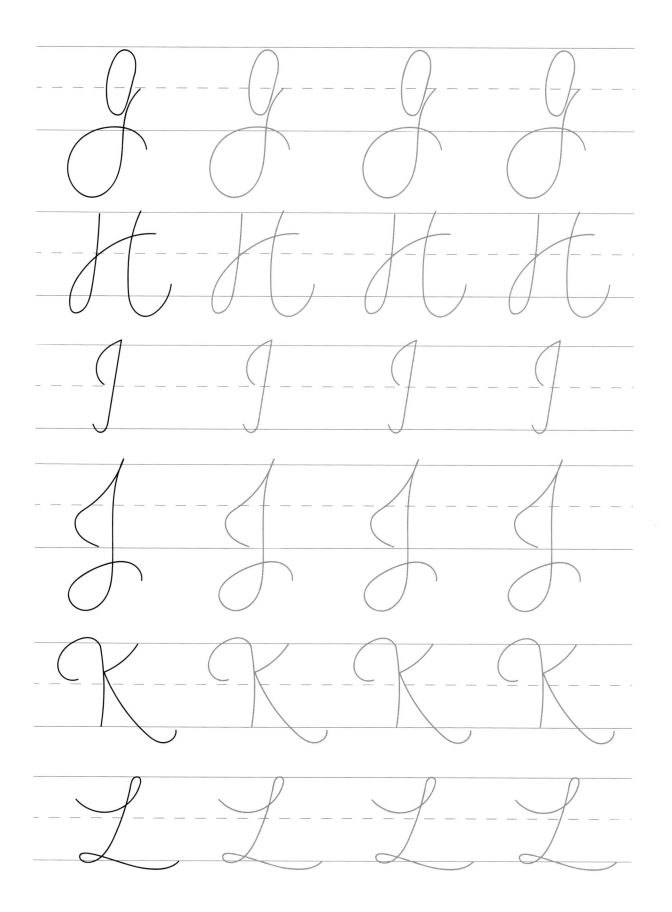

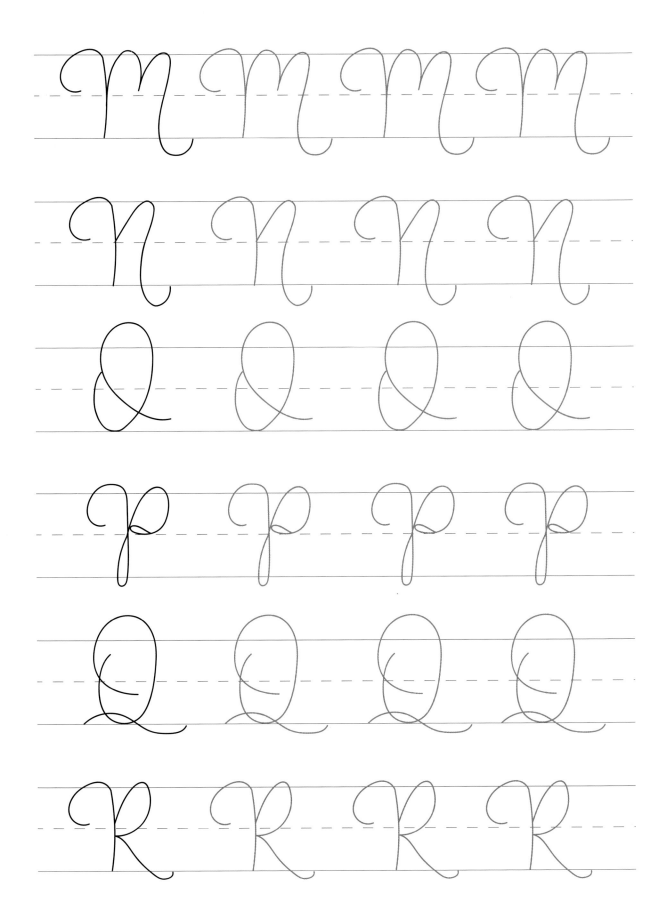

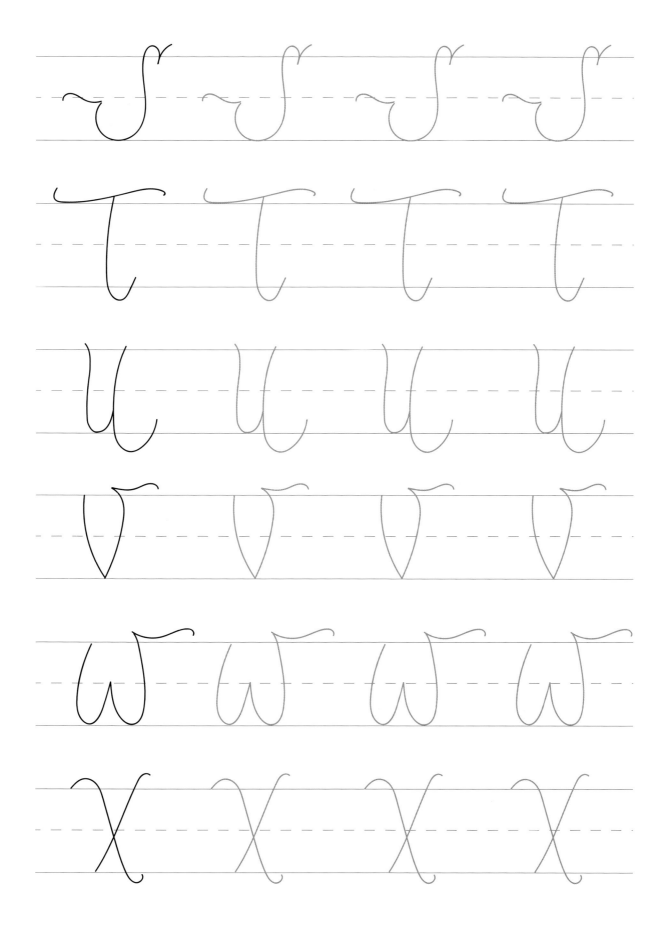

y y y y y

z z z z z

1 2 3 4 5

6 7 8 9 0

1 2 3 4 5

6 7 8 9 0

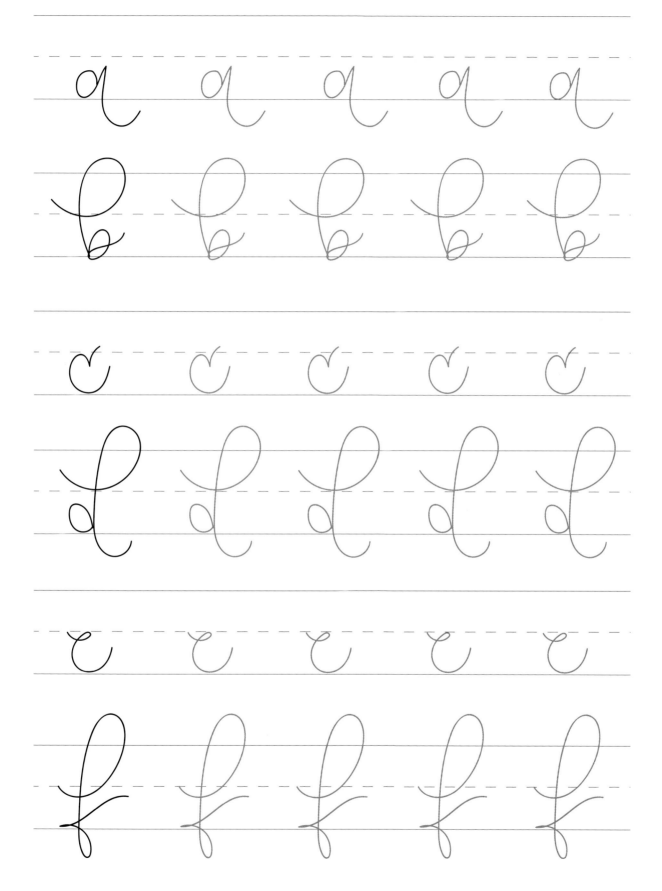

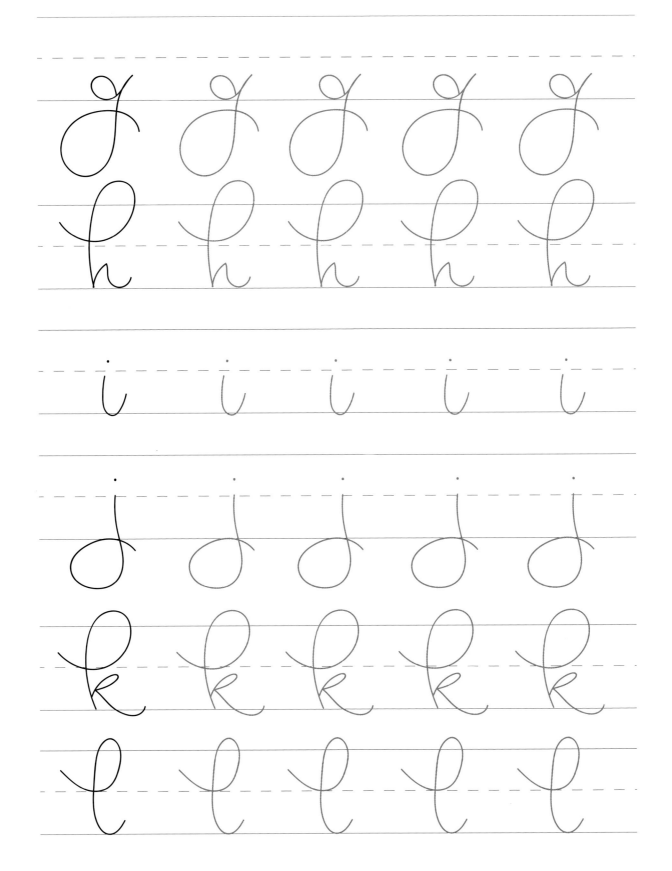

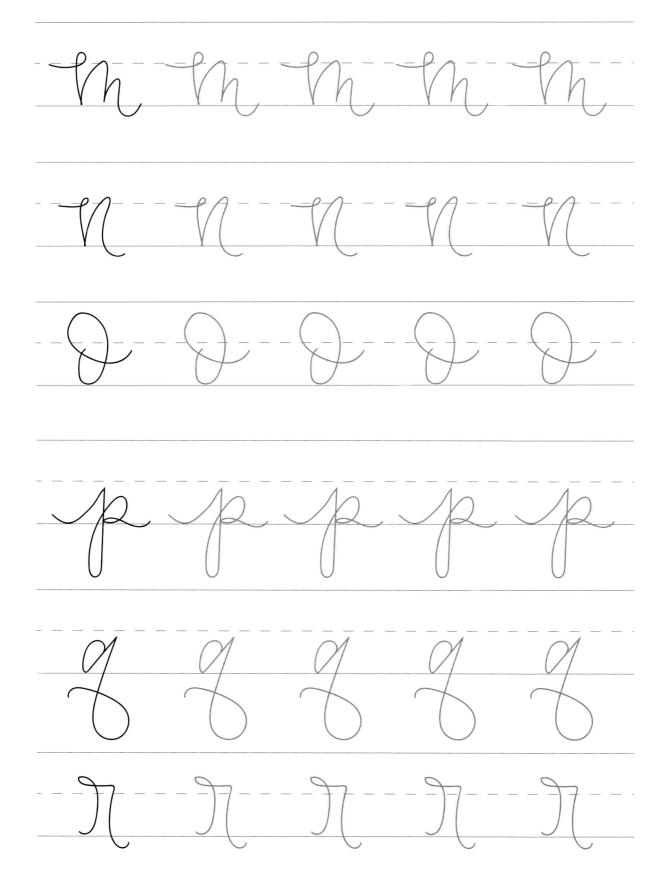

y y y y y

z z z z z

The quick
brown fox
jumps over
a lazy dog.

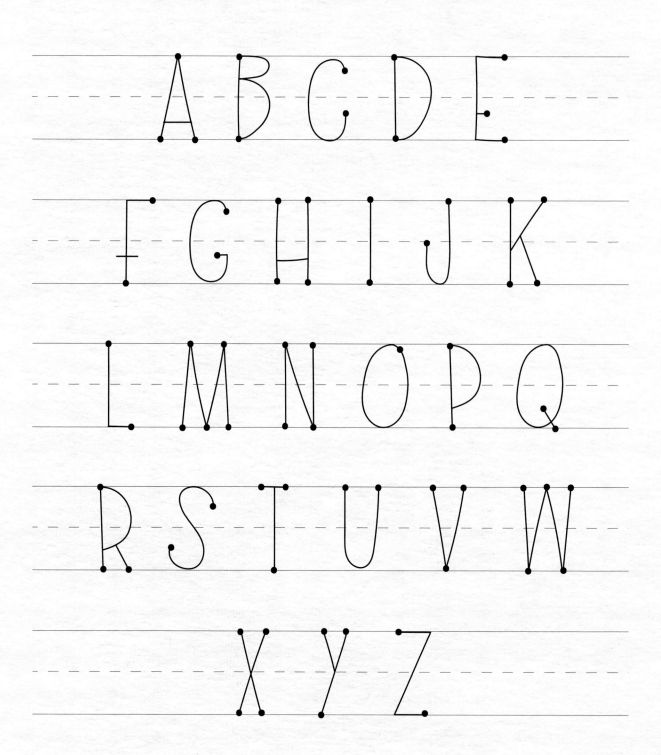

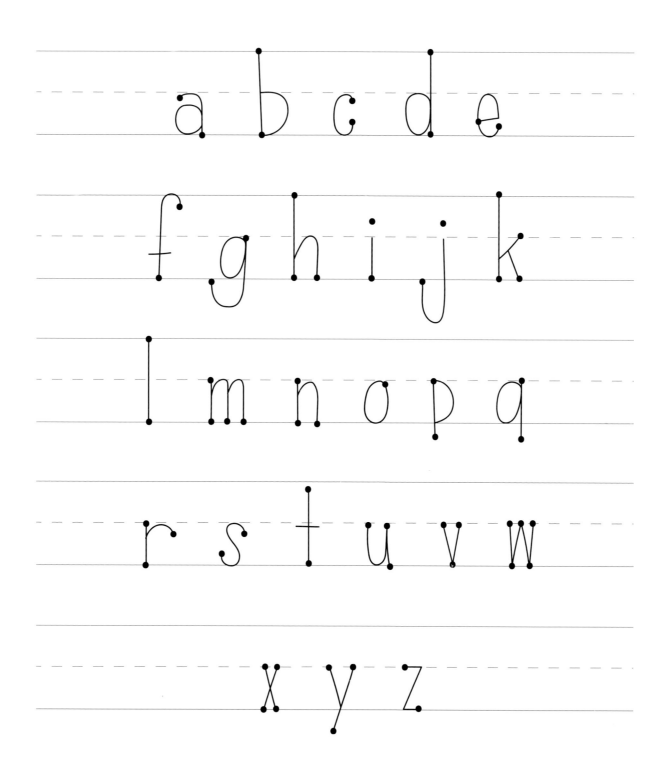

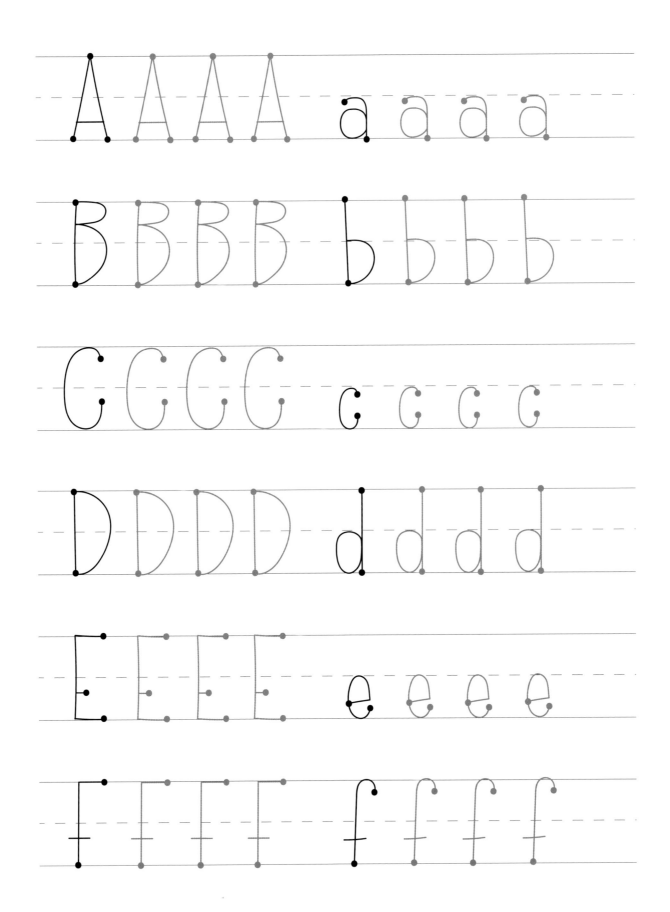

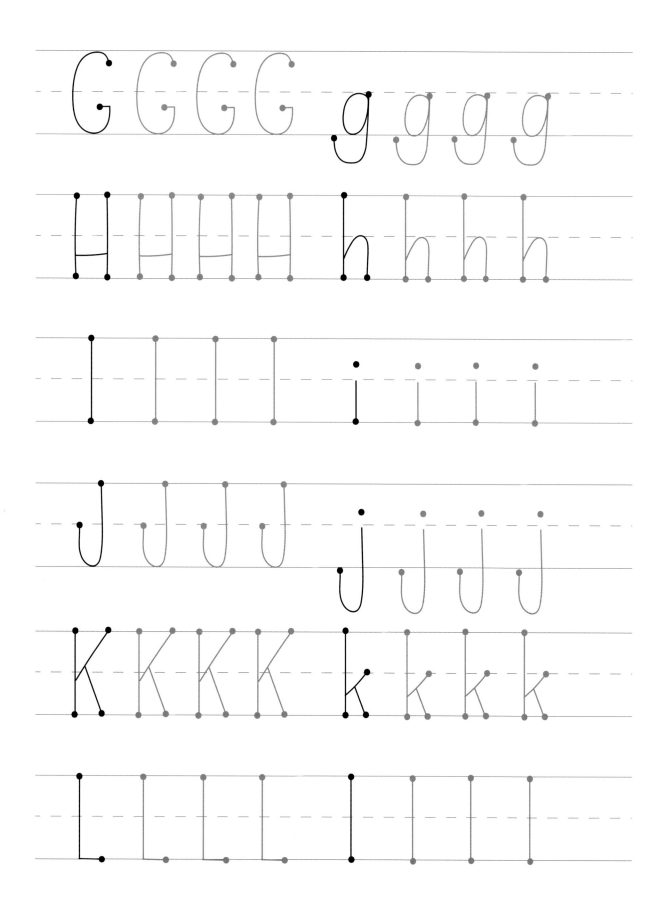

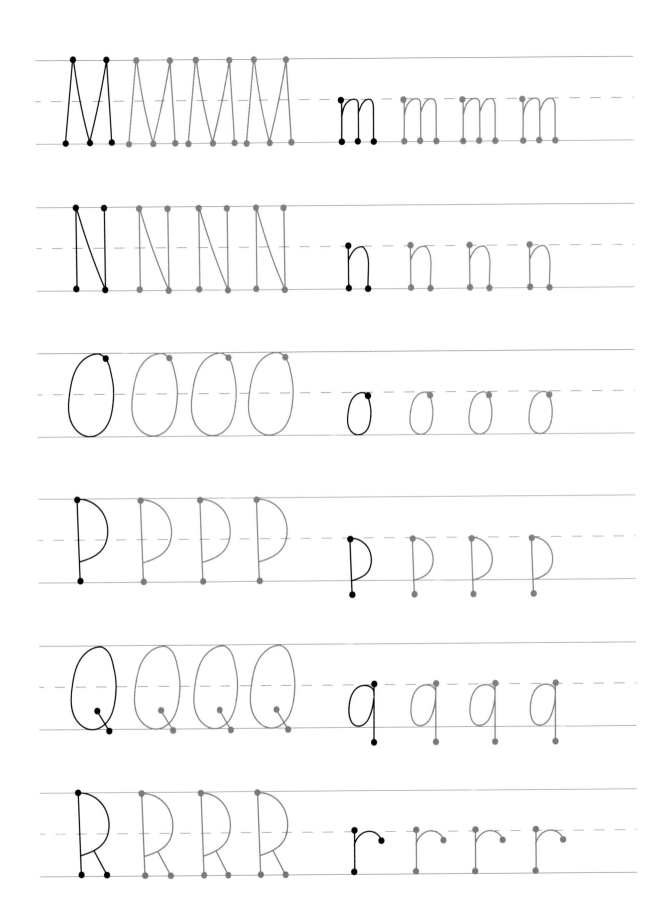

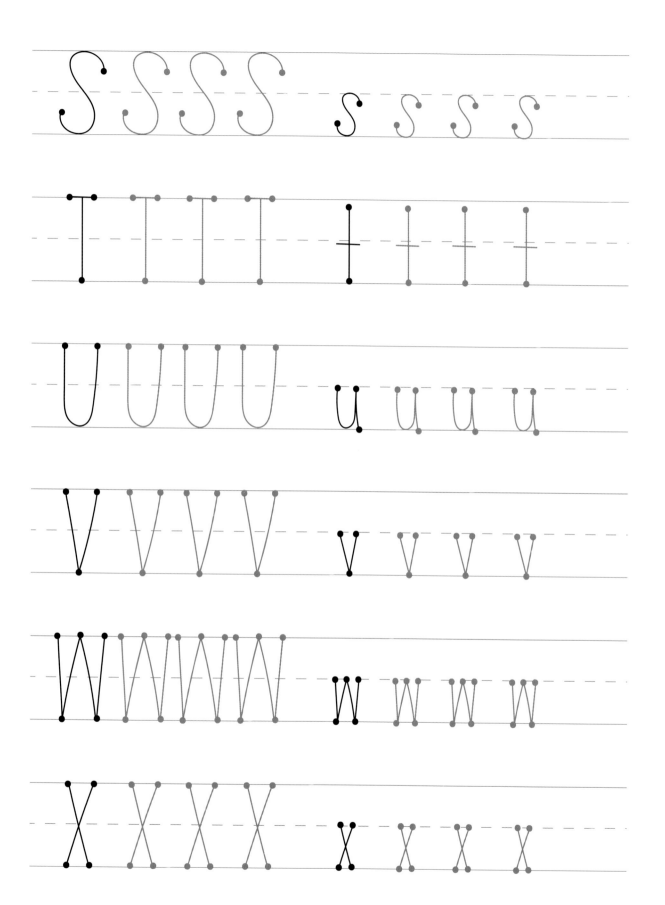

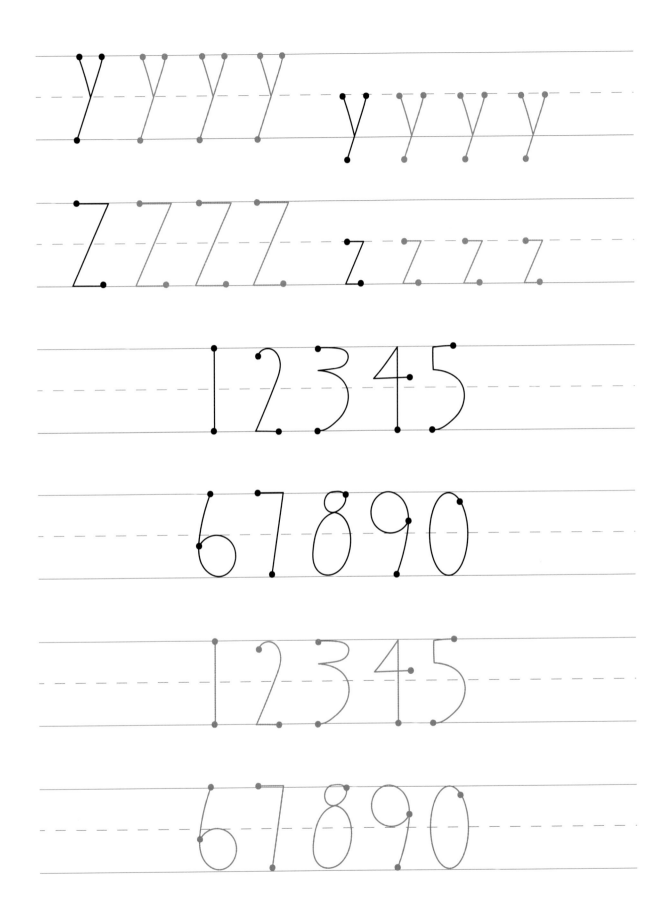

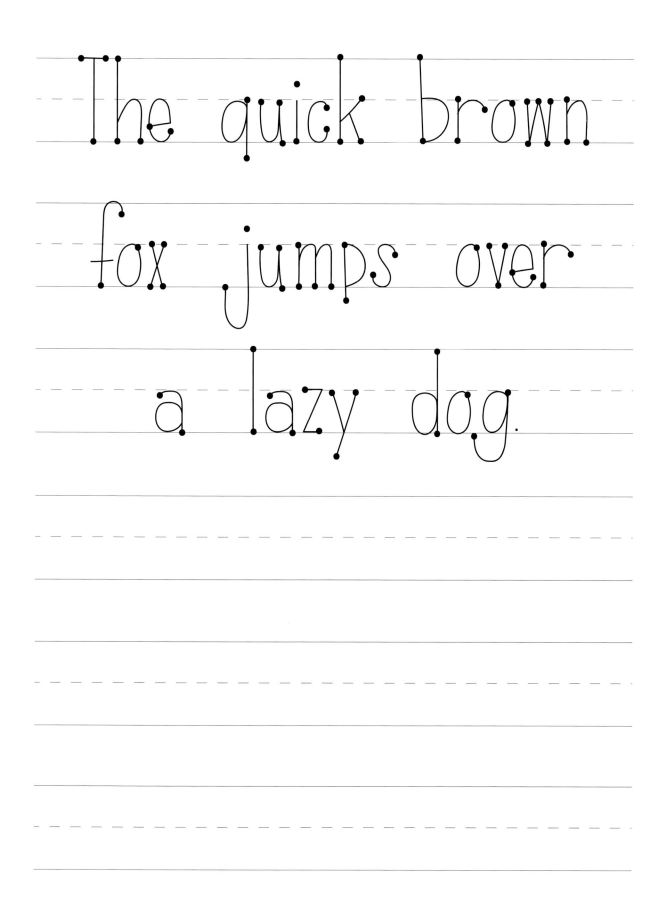

The quick brown
fox jumps over
a lazy dog.

ABCDEFGH

IJKLMNOP

QRSTUVW

XYZ

abcdefg

hijklmn

opqrstu

vwxyz

A A A a a a

B B B b b b

C C C c c c

D D D d d d

e e e e e e

F F F f f f

y y y y y y

z z z z z z

12345

67890

12345

67890

The quick brown fox jumps over a lazy dog.

ABCDEFGH

IJKLMNOP

QRSTUVW

XYZ

abcdefg

hijklmn

opqrstu

vwxyz

A A A A a a a a

B B B B b b b b

C C C C c c c c

D D D D d d d d

E E E E e e e e

F F F F f f f f

M M M M m m m m

N N N N n n n n

O O O O o o o o

P P P P p p p p

Q Q Q Q q q q q

R R R R r r r r

Y Y Y Y Y y y y y y

Z Z Z Z Z z z z z z

1 2 3 4 5

6 7 8 9 0

1 2 3 4 5

6 7 8 9 0

The quick brown
fox jumps over a
lazy dog.

ABCDEFGHI

JKLMNOPQ

RSTUVW

XYZ

abcdefg

hijklmn

opqrstu

vwxyz

C C C J J J a a a

c c c f f f g g g

> The letters C, J, a, c, f, g, j, r, and y have an additional step shown below. Write the letter with a thin micron pen and then "stamp" the circle with a larger marker to keep the circles consistent.

j j j r r r y y y

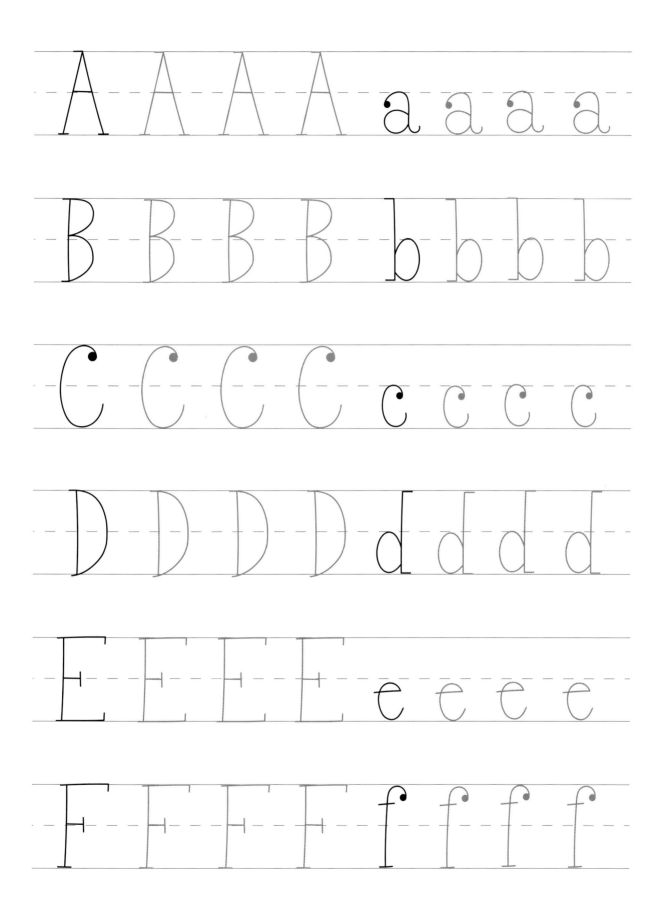

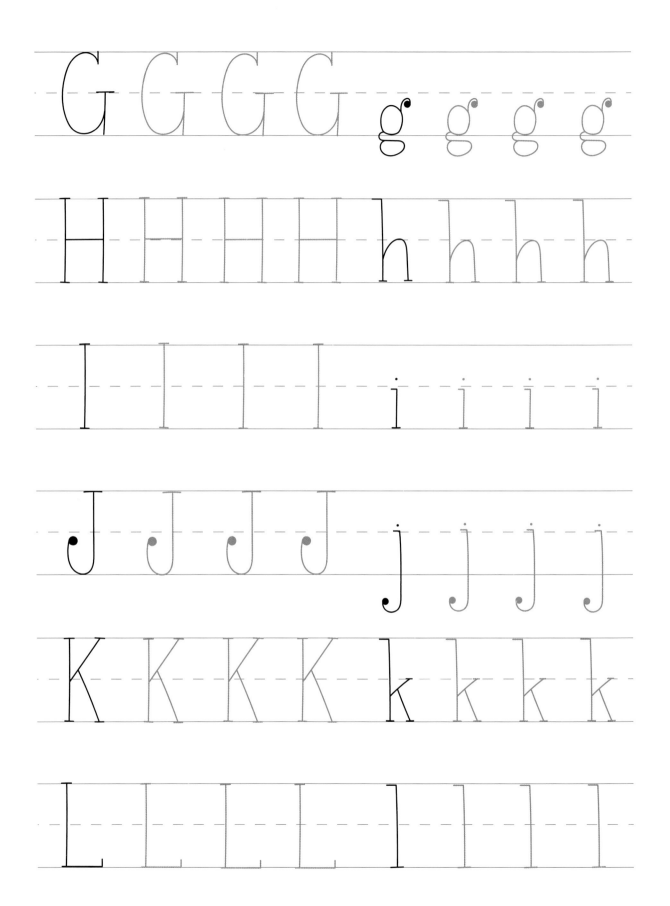

M M M M M m m m m

N N N N N n n n n

O O O O O o o o o

P P P P P p p p p

Q Q Q Q Q q q q q

R R R R R r r r r

S S S S s s s s

T T T T t t t t

U U U U u u u u

V V V V v v v v

W W W W w w w w

X X X X x x x x

Y Y Y Y y y y y

Z Z Z Z z z z z

1 2 3 4 5

6 7 8 9 0

1 2 3 4 5

6 7 8 9 0

the quick
brown fox jumps
over a lazy
dog.

monoline

a b c d e
f g h i j k
l m n o p
q r s t u v
w x y z

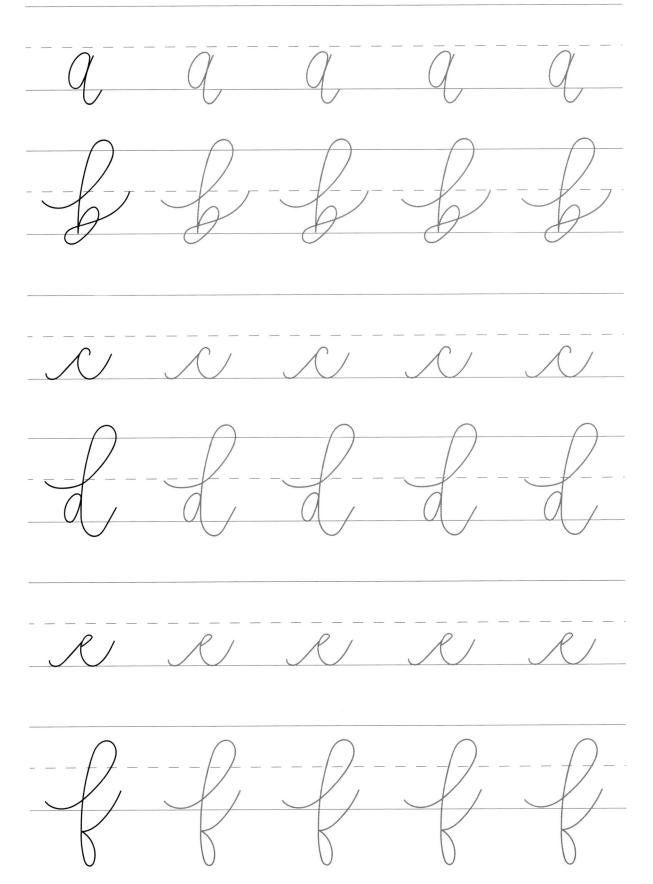

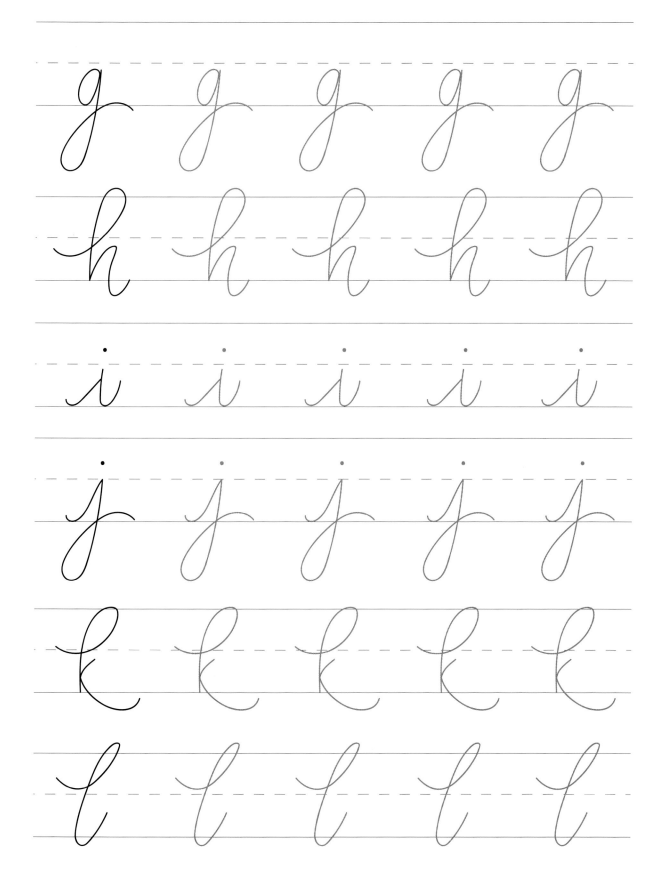

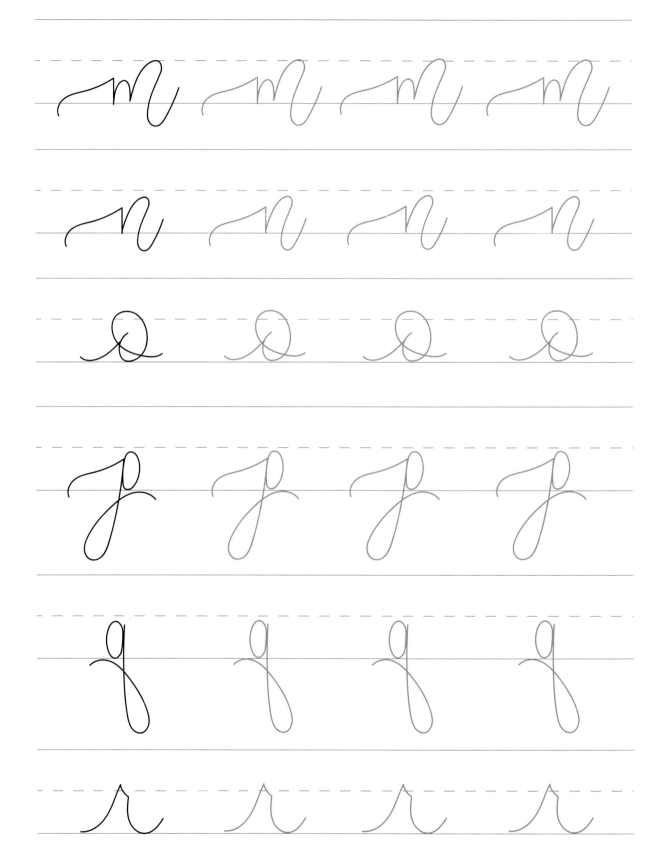

y y y y y

z z z z z

1 2 3 4 5

6 7 8 9 0

1 2 3 4 5

6 7 8 9 0

the quick brown fox jumps over a lazy dog.

ABCDEFGHIJKLM

NOPQRSTUVWXYZ

abcdefghijklm

nopqrstuvwxyz

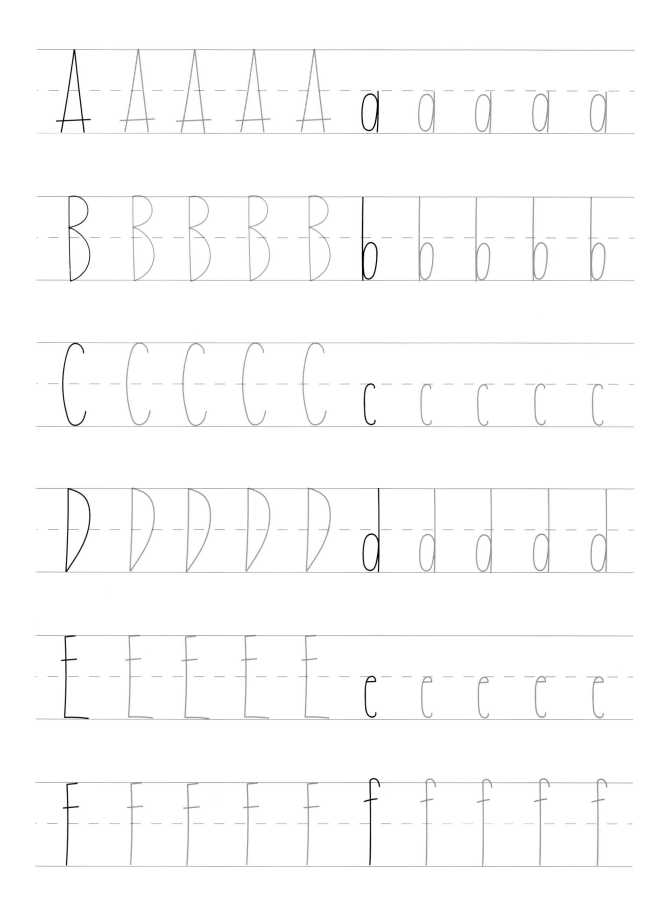

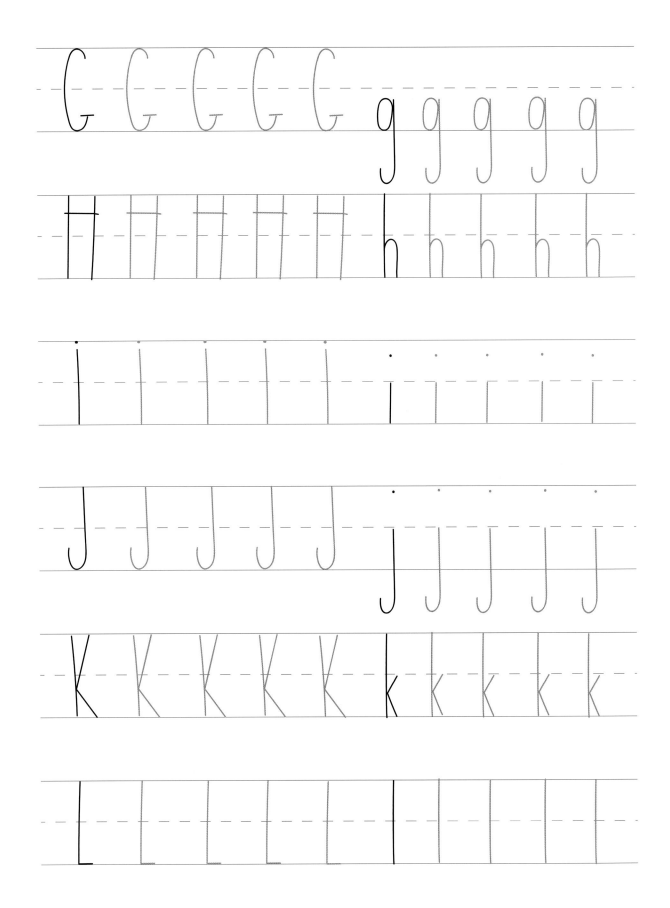

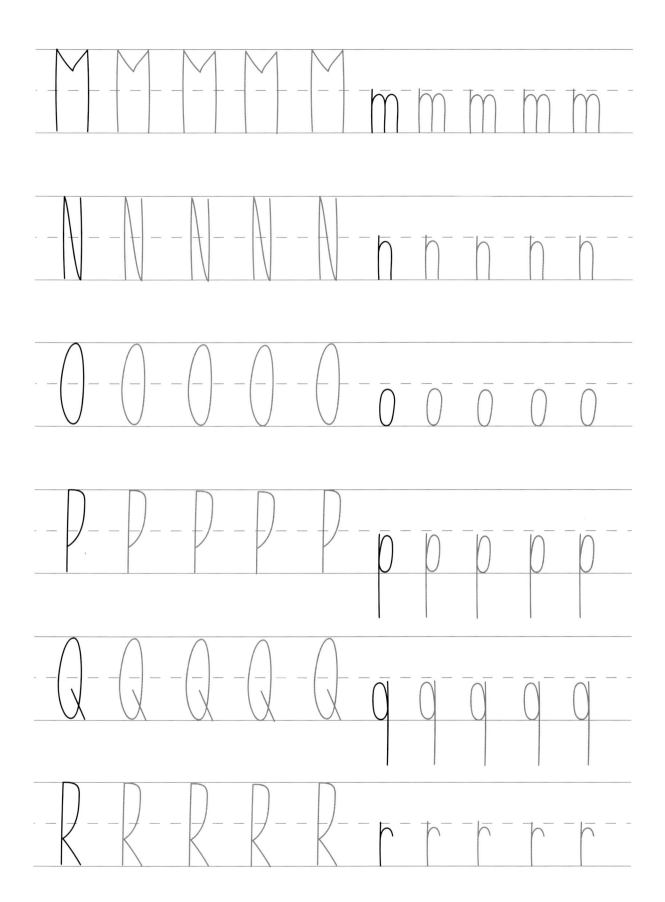

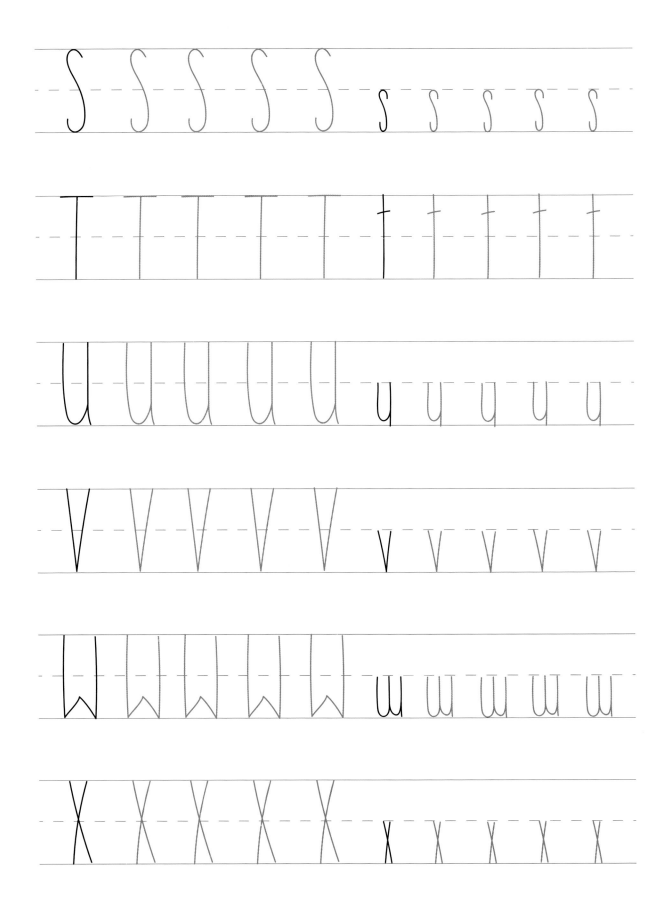

Y Y Y Y Y Y y y y y y y

Z Z Z Z Z Z z z z z z z

1234567890

1234567890

the quick brown fox jumps

over a lazy dog.

THE QUICK BROWN FOX

JUMPS OVER A LAZY DOG.

Mix-and-Match Styles

IT IS COMPLETELY NORMAL to get excited about learning so many new lettering styles and feel a temptation to use them all in a single piece. This approach may have a certain flair, but it is more likely to drive the eye crazy, bouncing from one lettering style to the next. A better strategy: try selecting just two lettering styles to pair together.

DESIGN TIPS

I like to spend a little time planning out different combinations of lettering styles before settling in on a pair. Two design considerations that can help:

- **TRY TO AVOID MIXING CALLIGRAPHY SCRIPT STYLES TOGETHER.** Instead, match a calligraphy script with a print. Bouncy and Monoline are both modern calligraphy alphabets that bounce below the baseline but when placed together can look messy. For a better pairing, try Bouncy and the more measured and neat Block. See the beautiful results in the Happy Birthday example on page 171.

- **CHOOSE LETTERING STYLES THAT MATCH THE NEED.** Are you creating a lettering piece for a nursery? Craft and Dot have a youthful look that make them great choices. Are you making a sign for a wedding? RSVP, Flow, and Holiday would work well for a formal event. Whether you are selecting a singular style or pairing to use, always consider readability, audience, and

other art or photos you plan to incorporate into the design.

In the examples on the following pages, I hope you find inspiration and see the gorgeous possibilities that come with adding new lettering styles to your toolbox. Happy mixing and matching!

DISCOVERING COMPATABILITY

Here, you can see the 15 distinct fonts you have practiced throughout this book all together. Gathering them may help you see what could work for attractive pairings. On the next page, see what happens when you try to integrate all the styles at once—total confusion!

bouncy

flow

Brush Print

script

holiday

R S V P

mountain

Faux Calligraphy

Sunshine

Dot

Cafe

Block

Typewriter

monoline

Craft

Sunshine Mountain Typewriter

holiday

script or s

flow ov op

Cafe

monoline

Brush Print

bouncy Dot

Block

Craft

Faux Calligraphy

THANK
YOU

Thank You

thank *you*

thank

YOU

Happy Birthday

happy *birthday*

HAPPY *birthday*

happy BIRTHDAY

Happy *birthday*

hello
gorgeous

hello
gorgeous

hello
gorgeous

hello
GORGEOUS

HELLO
gorgeous

hello
gorgeous

you are my

sunshine

you are my

SUNSHINE

you are my

sunshine

you are my

sunshine

PRACTICE
makes
PROGRESS

practice
makes
progress

PRACTICE
makes
PROGRESS

DISCOVER EVEN MORE
Hand-Lettering Inspirations!

HAND-LETTERED HOME IS THE NEXT STEP IN YOUR LETTERING JOURNEY.

- Twenty beautiful projects take your hand lettering to new levels.

- Step-by-step instructions guide you to gorgeous signs.

- Add modern farmhouse style to every area of your home.

- Craft custom gifts for loved ones.

- Nurture your creativity with design variations for every project.

YOU'LL TREASURE THE MEANING AND MEMORIES HAND-LETTERED SIGNS CAPTURE FOR YOU AND YOUR FAMILY!